ONLY IN ASHEVILLE

For Buddy,

Keep Asheville unique and eclectic. I hope you enjoy the stories in this book.

Marla Hardee Milling

June 2015

ONLY IN ASHEVILLE

MARLA HARDEE MILLING

AN ECLECTIC HISTORY

FOREWORD BY
Leslie McCullough Casse

THE
History
PRESS

Published by The History Press
Charleston, SC 29403
www.historypress.net

Cover images: Front cover: Yarn bombing on Wall Street. *Photo by Marla Milling*; Sister Bad Habit riding beside the LaZoom bus. *LaZoom*; Asheville's skyline as conceived by artist Jeff Pittman, used with permission; Asheville's Drum Circle in Pritchard Park. *ExploreAsheville.com*; and artist Kurt Thaesler's Day of the Dead chalk graffiti scene spotted on the "Before I Die" wall on Biltmore Avenue in the fall of 2014. *Photo by Marla Milling*. Back cover: Asheville Zombiewalk, fall of 2014. *Photo by Marla Milling*; overlooking Asheville. *Photo by Zen Sutherland*.

First published 2015

Manufactured in the United States

ISBN 978.1.62619.970.5

Library of Congress Control Number: 2015936221

Notice: The information in this book is true and complete to the best of our knowledge. It is offered without guarantee on the part of the author or The History Press. The author and The History Press disclaim all liability in connection with the use of this book.

Dedicated to the four most important people in my life:

My dad,
Ray Hardee

My maternal aunt,
May Shuford

And my children,
Ben and Hannah

CONTENTS

FOREWORD

I have often joked that George Vanderbilt was Asheville's first "trustafarian." That is the name Asheville residents gave the young pre-millennials who suddenly appeared in our city in the 1990s armed only with their creativity, a love of the landscape and an apparently endless source of independent funds.

It's a wonderfully humorous thought: Vanderbilt, the multilingual scion of a railroad fortune, sharing the same *joie de vivre* as a plaid-shirted hipster when he took his inheritance and left the Northeast to live and recreate in our small pocket of Appalachia.

It could seem the most fabulous of whims, but that would belie the impact his vision had on Asheville, architecture, forestry and land management—on an entire region—when he purchased what I was told as a child was "all the land as far as the eye could see" from what would become the grand porch of America's largest private home, the Biltmore Estate.

In his pursuit to build a European-style castle-home, he corralled world-famous designers and landscape architects. From Fredrick Law Olmsted of Central Park fame to Spanish architect and builder-with-tile Raphael Guastavino, it is impossible to overestimate the influence these artisans had on the city. Many of them would never return to Europe. They would construct their own residences here and develop their trades.

Asheville had always been a tourist town. From its earliest days, it wooed visitors who came to spend time in the expansive, rugged mountains either for health reasons, the four-season climate or the natural beauty.

After completion of the estate, it would draw a community of moneyed vacationers, investors and builders who would develop everything from inns to boarding schools. To grow up as a child in Asheville was to be surrounded by their stately buildings and residences. It was to know beauty and history.

There were games of tag in the hallways of the then-seasonal Grove Park Inn, with its storied Art Deco parties, massive stone lintels and Roycroft furniture. High school photos were taken in front of the large rock portals that framed the Blue Ridge Parkway's tunnels. They were hand-hewn by the Troitinos, relatives of classmates. Gargoyles hung above your head from the Neo-Gothic corners of the area's first skyscraper. Faces carved by the estate's English stonemason, Frederic Miles, stared at you from Asheville's oldest commercial building, the Drhumor Building.

Summer jobs meant explaining to tourists little facts picked up along the way: "The woodwork of the Cedar Crest Inn is second only to the woodwork in the Biltmore House." You knew school would be out soon when you saw the faces of those who summered here. There were editors from New York magazines who retired here and people from all over the world who came and created a life in what was then called "Asheville, Land of the Sky," or "Cool, Green, Asheville."

It did not seem exotic that I would spend two days as a child at a large estate sale in a rambling structure called Zealandia, a Tudor mansion named after the home of its first occupant, a New Zealand diplomat. Even the Richmond Hill estate, now burned down, had sprawling porches that were only trumped by an actual thank-you note in the foyer handwritten by Thomas Wolfe himself to the owner's daughter. After *Look Homeward, Angel* had caused a scandal with the locals because it was a too-unvarnished account of identifiable people, she penned a lone note of appreciation. In Wolfe's response, he said he had always seen the Richmond Hill house above the river and wondered what kind of a person lived in such a resplendent home, but after her letter, he knew the occupants were as grand and wonderful as the building itself. Even Thomas Wolfe, it seems, grew up with an awareness of Asheville's unique structures and considered the lives of the inhabitants inside.

I once gave a toast celebrating John Cram's contributions to our city. Cram catapulted the arts in Asheville when he not only developed the first thriving art gallery in Biltmore Village in the early '70s but then also helped revitalize downtown by locating galleries in the city's center and restoring a historic movie theater into a successful venue for art films. I told the gathered people that Asheville has always been a city of artists, authors and architects,

and John recognized that. From the moment he set foot in Asheville, he added to that vibrant history by refusing to settle for anything less than what Asheville deserves: a commitment to quality, substance and beauty.

Yes, Asheville's been a tourist town for a long, long time. But it took people like Vanderbilt, Cram and the people Marla Milling now highlights in her wonderful book to create the sophisticated artistic destination that is our city. It is an ambitious undertaking for a native like Milling to write about so personal a subject as her hometown. Even Wolfe wondered in *You Can't Go Home Again* "why he had always felt so strongly the magnetic pull of home… this little town and the immortal hills around it. He did not know. All that he knew was that the years flow by like water, and that one day men come home again."

Asheville declined because of the Great Depression, but once it paid off its debt in 1976, it began a second renaissance. Artisans have come, and artists have stayed. Tourists have come, and tourists have remained. It's not your typical history. It made them feel good to be here. At first it was the mountains. Then it was the city itself. Now, we see a third renaissance as more people discover, create, preserve and design.

Someone recently asked me how I felt about all the people moving here and Asheville's inevitable continued growth. I told them most of the longtime residents I know, or their forebears, came to these mountains at one time or another as visitors. They felt the primeval pull of these mountains and discovered what felt like home. They stayed because they were drawn to a sense of place, not just from the elegant architecture but also from the mountains themselves, which are the oldest in the world.

As Thomas Wolfe acknowledged in *Look Homeward, Angel*, "The mountains were his masters. They were rimmed in life. They were the cup of reality, beyond growth, beyond struggle and death. They were his absolute unity in the midst of eternal change."

LESLIE MCCULLOUGH CASSE

ACKNOWLEDGEMENTS

I've been mindful of gratitude during the process of writing this book. So many people helped me along the way, and I knew then, and continue to know now, that this book was not an individual effort. I became the vehicle to tell the story, but without the people who granted interviews, offered pictures and encouraged me every step of the way, this book would never have had a chance to see print.

The first, and perhaps the most important, person to thank is Banks Smither, the North Carolina commissioning editor at The History Press in Charleston, South Carolina. He believed in my proposal, and along with his editorial board, he gave me the unique opportunity to write this book. I appreciated his prompt, open communication and the caring support he offered as he guided me through the process of becoming a published author. Additional applause goes to Ryan Finn for the careful copyediting of this manuscript.

There are two people who deserve special recognition because without them, I really don't know where I'd be today. They have stood by me throughout the hills and valleys of my life and have always encouraged my goals and dreams. Thank you to my dad, Ray Hardee, and my maternal aunt, May Shuford, for your unconditional love and support throughout my life and most especially during this new venture. My Aunt May, a retired editor with the U.S. Forest Service's Southeastern Station, also served as an advance reader, proofreader and editor of my manuscript.

My children, Ben and Hannah, deserve medals for dealing with a stressed-out writer mom who seemed to be constantly interviewing and writing. They've

ACKNOWLEDGEMENTS

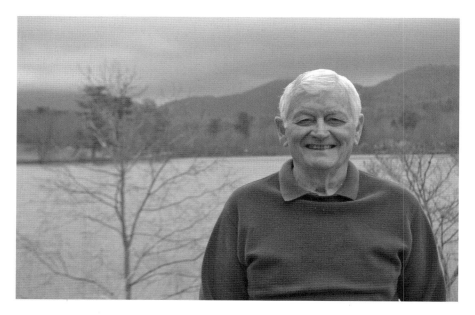

Author's dad, Ray Hardee. *Photo by Marla Milling.*

Author's maternal aunt, May Shuford. *Photo by Marla Milling.*

ACKNOWLEDGEMENTS

Above: Author's daughter, Hannah Milling, in one of her favorite downtown spots: Karen Donatelli Cake Designs at 57 Haywood Street. *Photo by Marla Milling.*

Right: Author's son, Ben Milling, checking out some downtown graffiti. *Photo by Suzie Heinmiller Boatright.*

extended so much patience as I've completed this book. They also spent hours downtown with me and listened to some of the same stories again and again as I pointed out spots from my childhood and places that are special to me. We've also found some new special places of our own.

I extend my greatest thanks to Leslie McCullough Casse for agreeing to write the foreword for this book. Like me, she's spent her life in this place and loves it to its core. Leslie is one of the most brilliant, vivacious women I know. She's a journalist; a lawyer; a devoted daughter, wife and mom; and co-owner of the AsheVillain skateboard company. She's deeply connected to helping Asheville grow in a positive manner and spearheaded a collaborative plan to move the University of North Carolina–Asheville (UNCA) and the city of Asheville forward with the creation of the McCullough Institute. I'm honored she contributed to this book, as well as appreciative of the champagne celebratory lunch we shared at Carmel's when I received the book contract.

My childhood friend Suzie Heinmiller Boatright also deserves my deep appreciation. She offered me an abundance of encouragement and support, and she also gave me the gift of her photography talent by taking my author photo. It appears at the back of this book. She's amazing.

Zen Sutherland allowed me to interview him about Asheville's street art and murals that he has documented over the years, and he also granted permission to reprint many of his photographs in this book. I am ever grateful to him for sharing his talent and offering his support and assistance. Even when the publisher didn't share my vision of including a color insert of photographs in this book, Zen very graciously allowed his photos to be printed in grayscale. This is a great example of the community vibe in Asheville. I didn't know Zen and his beloved wife, Helen, until embarking on this project. Kitty Love suggested I talk with him, and that led to friendship and collaboration.

In addition, I encountered some very helpful folks when I was in the search of archive photos. Lyme Kedic at the North Carolina Collection at Pack Memorial Library and Gene Hyde in Special Collections at D.H. Ramsey Library at the University of North Carolina–Asheville both jumped into quick action when I found I needed some last-minute photos during production. Lyme also helped me a great deal during my research, as did Zoe Rhine at Pack Library. Zoe gladly brought out box loads of information for me to review from the Save Downtown Asheville Campaign. I also appreciate the assistance of Ruth Summers at the Grove Arcade, Tracey Johnson-Crum at the Omni Grove Park Inn, Sarah Lowery at ExploreAsheville.com and Doug Maurer of the Asheville Tourists.

ACKNOWLEDGEMENTS

I'm extremely grateful for all of the people who took time out of very busy schedules to share memories with me and allow me to quote them in this book, as well as offer photo support:

- Leah Ashburn, president of Highland Brewing.
- Byron Ballard, Wiccan High Priestess/"Asheville's Village Witch."
- Lou Bissette, attorney and former Asheville mayor.
- Bill and Shelagh Byrne, former owners of Café on the Square Restaurant.
- Wayne Caldwell, author of *Cataloochee* and co-owner of Ambiance Interiors.
- Franzi Charen, founder of Asheville Grown Business Alliance and owner of Hip Replacements.
- Gary Charles, owner of G Social Media and AskAsheville.com.
- Jan Davis, owner of Jan Davis Tire Store and current member of Asheville City Council.
- Joan Eckert, co-owner of Laughing Seed Café.
- Rob and Lynn Foster, owners of Buffalo Nickel Restaurant.
- Peggy Gardner, Asheville historian.
- Greg and Ashley Garrison, owners of the Hop Ice Cream Café and the Hop Ice Creamery.
- Bob Gunn, architect.
- Ted Katsigianis, VP of agriculture and environmental sciences, Biltmore Estate.
- Ryan Kline, executive chef, Buffalo Nickel Restaurant.
- Aaron LaFalce, singer/songwriter and midday host at 98.1, The River.
- Jim Lauzon (aka "Sister Bad Habit"), co-owner of LaZoom.
- Kathryn Long, co-owner of Ambiance Interiors.
- Ralph Longshore, "the Man in White" living statue.
- Kitty Love, executive director, Asheville Arts Council.
- Meg MacLeod, widow of Julian Price.
- Pat McAfee, author, retired English/drama teacher at T.C. Roberson and A.C. Reynolds High Schools and former owner of the Ancient Page Bookstore in Asheville.
- Tom Muir, historic site manager at the Thomas Wolfe Memorial.
- April Nance, former public relations director, Southern Highland Handicraft Guild and Folk Art Center.
- Kathi Petersen, senior vice-president, AdvantageWest.
- Jeff Pittman, River Arts District artist.

ACKNOWLEDGEMENTS

- Grace Pless, chair of Urban Trail committee.
- Darren Poupore, chief curator, Biltmore Estate.
- Mike Rangel, co-owner, Asheville Pizza & Brewing Company.
- Jael Rattigan, co-owner, French Broad Chocolate Lounge.
- Milton Ready, retired UNCA history professor and author of a number of books, including *Remembering Asheville*.
- Constance Richards, author, journalist, art gallery director and widow of Vadim Bora.
- Abby "the Spoon Lady" Roach, busker.
- Jan Schochet, Asheville historian.
- Tiziana Severse, hairstylist and singer.
- Heidi Swann, co-founder of aSHEville Museum.
- Sandy and Larry Waldrop, owners of Grovewood Café.
- Joshua P. Warren, paranormal expert, author, owner of the Asheville Mystery Museum, and creator of the Haunted Asheville ghost tours.
- Pat Whalen, Public Interest Projects.
- Ian Wilkinson, mural artist.
- Oscar Wong, founder of Highland Brewing.

I conducted interviews in a wide variety of places, and I think it's important to mention them because they all play into the creative process of writing this book: Ambiance Interiors; Asheville Arts Council in the Grove Arcade; aSHEville Museum; Aubergine Salon; the law office of Lou Bissette, located in one of my favorite downtown buildings, the Drhumor Building (pronounced "drummer"); Jan Davis Tire Store; Jeff Pittman Art Gallery in the River Arts District; the offices of Public Interest Projects in the rear of the George Vanderbilt Apartments; the Thomas Wolfe Memorial, and via Skype at Meg MacLeod's home in Holland.

Interviews also took place at a variety of area restaurants and bars: Barley's, Buffalo Nickel, City Bakery, Double D's Coffee & Desserts, Early Girl, French Broad Chocolate Lounge, Grovewood Café, Highland Brewing Company, Laughing Seed Café, Nine Mile (Montford), Odd's Café, Olive or Twist, Raven & Crone, Sovereign Remedies, Strada Italiano, the Hop Ice Creamery, Wasabi and World Coffee Café.

I also worked solo in places like True Confections and BurgerWorx in the Grove Arcade, Gourmet Chip Company on Broadway and Atlanta Bread Company on Merrimon Avenue.

I've enjoyed spending a lot of time downtown and acknowledge Asheville in and of itself. If ever a town had a true spirit, it's Asheville. I've felt it with

ACKNOWLEDGEMENTS

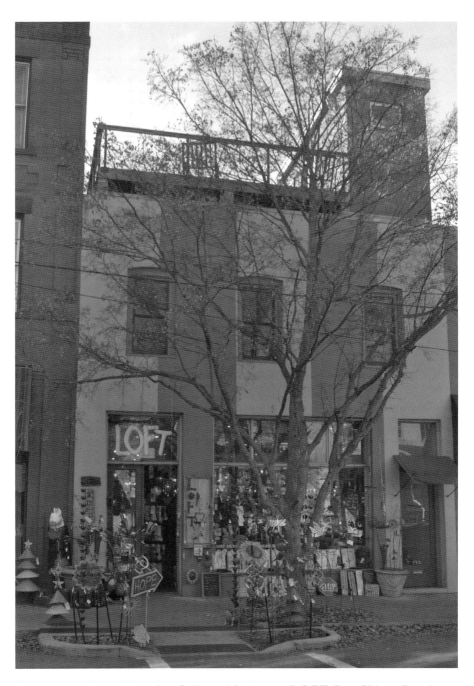

The author and her children love finding quirky items at L.O.F.T. (Lost Objects, Found Treasures) on Broadway. *Photo by Marla Milling.*

ACKNOWLEDGEMENTS

Aerial view of Asheville, North Carolina—a strange, quirky, marvelous, beautiful town. *Photo by Zen Sutherland*.

me, whispering in my ear as I walk among buildings that almost suffered the fate of being destroyed in the early 1980s.

Lucky for all of us, that tragedy didn't take place. We have much to be thankful about in our connection with Asheville and the people, past and present, who make it the weird, funky, progressive, magnificent place it is today. It's the most spectacular place on the planet, at least for me. I'm grateful I was born in this place and continue to make my home here.

INTRODUCTION

S ome call Asheville weird. Others call it the "Paris of the South," the "Santa Fe of the East," "Beer City, U.S.A.," the "New Age Capital of the World" or the "Happiest City in America." *Rolling Stone* magazine named Asheville the "Freak Capital of the World" in 2000, and *Travel and Leisure* called it the "Quirkiest Place in America" in 2014. You might have your own name for it. For me, it's always just been "home."

Asheville marches to a different beat—perhaps one coming from the drum circle on Friday nights in Pritchard Park. The drum circle features a random assortment of drummers pounding out a synchronized beat, surrounded by dancers, gawking tourists, hula hoopers and connected locals who love celebrating the contagious energy.

Defying stereotypes and canned descriptions is Asheville's forte. There are many differences among people in this town, and yet everyone seems to just coexist. There's a blending here of opposing ideas and cultures and experiences, yet for the most part it is an oasis of tolerance. It's also a place that can take criticism or a faux pas and poke fun at it. When a state senator in the piedmont of North Carolina dubbed Asheville "a cesspool of sin" in 2011, it just became a humorous slogan—it can still be found on T-shirts around town. The phrase even caught the attention of Peter Sagal, host of the NPR quiz show *Wait Wait…Don't Tell Me!* He recorded a message for WCQS radio's fund drive congratulating Asheville for its new distinction.

When Pauline Frommer appeared on *Good Morning America* in early 2015 to promote Frommer's "Best Places to Go in 2015," she touted Asheville as

A drummer pounds out a beat at the drum circle in Pritchard Park. This event takes place on Friday evenings in warmer weather. *ExploreAsheville.com.*

their number one pick but drew scrutiny when she said this: "We're picking [Asheville] this year because the sketchy riverside area has been totally redone thanks to New Belgium Brewery, which has poured millions of dollars into this area, making new parks, artists collectives, farmers markets, bike paths."

Local people quickly latched on to the term "sketchy" and scratched their heads over the claim that New Belgium Brewery, which hasn't even finished its new facility here, is somehow responsible for the success of the River Arts District. It's the creative energy of many artists who make the RAD popular and one of the reasons New Belgium saw it as a good place to open a brewery. Of course, instead of getting mad, the folks at Image 420 in West Asheville responded in true Asheville spirit by creating another T-shirt. This one says, "Still Sketchy After All These Beers."

Frommer was a bit premature in saying the river district had millions of dollars poured into it, but she is right about that money coming. On March 22, 2015, the *Asheville Citizen-Times* reported that upgrades in and around the River Arts District will reach $50 million within the next six years. The article added, "The infusion of public funding into a once derelict industrial district will be accompanied by about $200 million in private investment." The funneling of money and energy into this area will definitely transform

INTRODUCTION

Tiny mouse doors on the bottom of a Woodfin Street building lend to the magical, whimsical vibe downtown. *Photo by Hannah Milling.*

Asheville in ways that can only be imagined at this point. Big change is underway, and Asheville is only going to get bigger. It's my hope that it doesn't lose its uniqueness in the process.

Asheville is a place where, like Forrest Gump's box of chocolates, you never know what you're going to get or what you're going to see or experience. It might be discovering tiny mouse doors on the side of a building on Woodfin Street, spotting a gargoyle hanging over the side of the Jackson Building or catching a glimpse of some freshly painted graffiti on a rambling, vintage building.

You might also cross paths with a man dressed as a nun. He might be sipping beer in a local brewery or riding a cherry red bike. That nun, known as "Sister Bad Habit," is really Jim Lauzon, who owns the popular LaZoom tour bus with his wife, Jen. You'll read more about him later on, as well as other colorful Asheville personalities.

So what is it about this place? How did it become so unique and different from other places? Why is this place now winding up on just about every top ten list imaginable? In addition to the Frommer's 2015 nod, *Forbes* named it one of "America's Smartest Cities" in November 2014, and a National Geographic Travel book released in October 2014 named Asheville one of

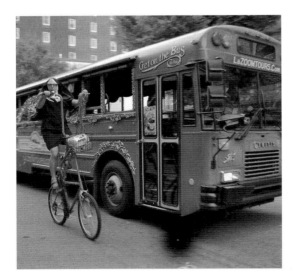

Left: Sister Bad Habit (aka Jim Lauzon) knows how to generate laughter and smiles when "she" rides alongside the LaZoom Comedy Bus. *LaZoom.*

Below: Ben's Tune Up features a restaurant and an amazing beer garden in a former auto shop. *Photo by Zen Sutherland.*

the "World's Best Cities." This town is innovative, exciting, progressive and anything but ordinary, but what is this incredible vibe all about? Those are the questions I set out to answer in this book.

Asheville is a vibrant, exciting place in 2015, but that's nothing new. It's been a vibrant, exciting place throughout history. It's continually evolving, though it's been through its share of rough moments in time. Despite the hardships, there's always been a mysterious pull, especially for creative

spirits, artists, musicians, nature lovers, writers, mystics and those seeking ways to more fully explore themselves.

It's been a place marked by great wealth and great talent. Even bad events can leave positive results, and that was the case of the Great Depression in Asheville. While it proved to be a severely difficult time in history, it also left Asheville with many of its architectural treasures. Asheville simply couldn't afford urban renewal, as it carried the burden of paying back every cent owed for projects completed in the Roaring Twenties. There was great enthusiasm in the '20s and a lot of opulence, as noted in the detailed architecture. Saving those treasures from a bountiful era lends itself to the positive vibe felt in town today.

As an Asheville native, I came into this project with a strong love for my hometown. My family, on both sides, has been in these mountains for generations. Like most early settlers to this region, it was a hardscrabble life, with people surviving through ingenuity, dedication and hard work and calming the soul through creative endeavors, music and laughter. Asheville is the product of that strong mountain spirit, as well as the wealth funneled in by others who have discovered this place along the way.

I have had the unique vantage point of watching this town evolve over a period of decades. I remember such things as the thrill of going to the big department stores downtown as a child, getting five-and-dime "treasures" at Woolworth's, rolling out a blanket on a summer night to watch Shindig on the Green and going to the dentist in the Flat Iron Building. I also remember when the Asheville Mall left a wake of empty stores downtown as the department stores left and others struggled to survive. I watched my hometown become a ghost of its former self in the '70s and '80s, when venturing downtown seemed pointless. When I talk of those days to people who didn't experience them and know Asheville only as a vibrant place today, they look a bit confused, not quite knowing how to react or even whether to believe the level of desolation I describe.

There was always a pulse, though. Even as Asheville struggled to survive, its heart kept beating and continued to pull artists, architects, authors, visionaries and risk takers, just as it always has. That's part of its uniqueness—Asheville continues to evolve and regenerate itself through the ages as enterprising citizens work hard to protect and preserve Asheville's livelihood.

Writing this book has also made me aware of many of the superlatives some people use to describe the town—"natives don't exist," "Asheville is just a sea of transplants," "you can't make a healthy living here" and "the vibe of artists and Bohemian spirits are being pushed out as the wealthy

INTRODUCTION

Beautiful in any season, but especially when the rhododendron are blooming, Asheville beckons amid the blooms, music and mountains. *Photo by Zen Sutherland.*

make this their home and playground." There are seeds of truth in these statements, but blanket generalizations are false. There are plenty of natives, and you'll read the words of quite a few in the pages of this book. I didn't seek out people because they are natives. I sought interviews with people who are genuinely connected with Asheville and contributing to its positive growth. As I thought back to the people I interviewed for this book, I was struck at how many are natives and who choose to continue to embrace this city with their energy, talents and love.

There are plenty of people making a good living in town and still plenty of the eclectic mix of personalities alive and well in downtown Asheville. And yes, the wealthy and tourists have been coming to these mountains for generations, so today's influx is just a continuation of that draw as a playground.

Who can blame people for coming here? The scenery inspires imagination and creativity. Outdoor activities are plentiful and run the gamut from hiking to whitewater rafting, zip lining, rock climbing, snow skiing, camping, canoeing, mountain biking, kayaking and taking on other challenges. The

INTRODUCTION

Chicken Alley mural designed by artist Molly Must. *Photo by Marla Milling.*

Blue Ridge Parkway, Mountains to Sea Trail, Appalachian Trail and Great Smoky Mountains National Park are all close enough to enjoy a multitude of outdoor experiences and natural treasures.

Throughout this book, I will reveal how the funky, weird, eclectic Asheville of today is the product of the hard work and dedication of a wide mix of visionaries, risk takers, renegades and creative souls. It's also a place shaped by incredible natural beauty, wealth, talent, dedication and a broad mix of personalities who live and spend time here.

I can't imagine living anywhere else.

STRANGE ALIGNMENT

There's a good feeling in this town. It's a little bit different.
—Beck during his concert on July 12, 2014,
at the Thomas Wolfe Auditorium in Asheville

Most everyone who encounters Asheville through personal exploration understands this place is different. It may have something to do with Asheville being located in the world's oldest mountains. The surrounding peaks are steeped in mystery and beckon to the hearts of eclectic, creative souls. There's also a high concentration of quartz in the mountains. Quartz is known for electromagnetic properties, which may also help explain this mysterious pull—some define it as an energy vortex.

Or maybe it's because Asheville is on a geographical alignment with a pattern of weird and unexplainable things. Joshua P. Warren thinks so. He's an Asheville native who has devoted his life's work to investigating the weird, strange and paranormal. He wrote his first book, *Joshua Warren's Museum of Mystery and Suspense*, when he was fourteen. He's gone on to write many books, including *Haunted Asheville* and *How to Hunt Ghosts*. He founded L.E.M.U.R. Paranormal investigations in 1995, and that same year, the Grove Park Inn resort hired him to investigate the inn's resident ghost, known as "the Pink Lady."

He's also the president of his multimedia productions company, Shadowbox Enterprises, and the owner of Haunted Asheville Ghost Tours, and in 2011, he established the Asheville Mystery Museum, located in the basement of

Joshua P. Warren, internationally acclaimed paranormal investigator, author, radio show host and owner of Asheville Ghost Tours and the Asheville Mystery Museum. *Joshua Warren.*

Asheville's Masonic Temple. He published his first novel, *The Evil in Asheville*, in 2000 and hosts the *Speaking of Strange* syndicated radio show.

Sitting at the bar at Olive or Twist, across from the Masonic Temple, Warren revealed something that makes so much sense when considering why Asheville is such a weird, eccentric and quirky place:

> *If you start with Asheville and you draw a line going east, you pass through the Brown Mountain area, where you have the Brown Mountain Lights. Then you pass the area where you have the Devil's Tramping Ground, this big barren circle where nobody knows why nothing will grow there. If you keep drawing that line, you'll hit the coast of North Carolina, where so many ships have sunk they call it the "Graveyard of the Atlantic." Draw that line off the coast and you hit Roanoke Island, the very first English settlement, where they arrived in 1590. All of them vanished, so it's now known as the "Lost Colony." Keep drawing that line out and you'll hit the island of Bermuda at the top point of the so-called Bermuda Triangle. So it's like we are part of a vast alignment of strangeness here. Some people would consider this the jewel of the crown. It seems to be part of a geometric pattern.*

Warren has cultivated an international reputation as a paranormal expert, and as such, radio stations from all over the world interview him frequently. He's become even more aware of Asheville's allure by the reaction he receives when he tells program hosts where he's from. "Right off the bat, they'll say, 'Oh wow, that's one of the most haunted, spookiest, weird places,' and they also consider it a wealthy, higher-class place now, so it seems like it's been a combination of wealthy people coming here, bringing resources and looking for entertainment, and some sort of shift that took place around the 1990s of people expecting a new phase of spiritualism connected to the mountains here."

He continued:

> In my own lifetime, when I was allowed to start coming down here on field trips and that kind of thing, most of this town seemed pretty dead. There wasn't much happening in that period of the 1980s. A lot of the area was pretty run-down. I would say it was sometime around the time I started writing Haunted Asheville, which was around the early to mid-1990s, when all of these New Age shops started to appear, and you had people like James Redfield, author of the Celestine Prophesy, going on CBS News and calling Asheville the "New Age Capital of the World." Once that happened, it seemed like the ball was irrevocably set in motion, and more and more of these workshops began appearing and more Bohemian street performers started showing up and it has just continued to exponentially grow until now.

When it comes to Asheville, Warren says it's the people who make the place so eclectic and different:

> You have people who are dressed in combinations from different cultures—some of them ancient, some of them unknown. Each has their own interpretation of philosophy and spiritualism, and most are more than happy to share it with you for better or for worse. Of wizard, warlock, witch, mystic and mystifier, and they are strewn randomly about the city, and we can't forget this is Beer City now and so I think, as usual, alcohol is just the right fuel for some of the profound wisdom that you hear espoused by these prophets on a late night.
>
> You don't know if you are going to run into a bartender who knows all about quantum physics or a vagabond who can play the banjo like you've

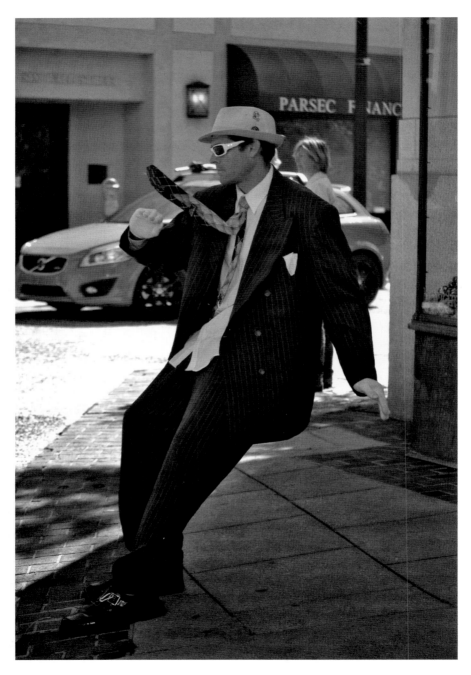

Street performer Dade Murphy at the corner of Wall Street and Battery Park Avenue. *Photo by Marla Milling.*

never seen in your life, or if you're going to meet someone who is absolutely demented and warped out of their mind. You never know what you're going to get. That's the weirdest thing. When people say Asheville's weird, that's what they are usually thinking. All of the paranormal stuff is quite normal compared to that.

DEEP, SLOW ENERGY

The energy in Asheville and surrounding mountains is "very deep and slow and strengthening," as described by Byron Ballard. She also cautions that it demands profound respect:

There's always new energy moving into this area. I am blessed when I am sitting at my computer table at home to look out over the French Broad River and know I am looking at the third-oldest river in the world, situated in the oldest mountains in the world. I tell folks all the time thinking that it's a New Age capital—that it's not all going to be lovely and glowing like Portland. That's not what the energy is here. The energy here requires you to come into relationship with the land, and if you don't do that or can't do that, Asheville spits you out. That's a part of Asheville we don't talk about much. It is welcoming here because it's a tourist town, so there's kind of a surface welcome to everyone—"Sure, c'mon in"—but to actually be part of here requires a kind of quietness of spirit to connect on a deeper level.

Ballard, a native, comes from a long line of ancestors who made their home in the Western North Carolina mountains. She's a Wiccan High Priestess, author and workshop leader. About six years ago, she was one of eight founders who created the Mother Grove Goddess Temple in Asheville, and she later established a business as "Asheville's Village Witch."

She grew up knowing that members of her family had special skills and talents and that she, as a female member of the family, would also receive some sort of gift. Today, she considers herself a "forensic folklorist" and is invested in collecting mountain spells and preserving "hillfolk hoodoo," a form of Appalachian folk magic. She's the author of several books, including *Staubs & Ditchwater: An Intro to HillFolks' Hoodoo*. She noted:

I come from a family that has for at least four or five generations back been called witches, but what that meant was not a religious thing at all because they were also good Methodists. My great-grandfather was one of the founders of the Methodist Church locally, and my grandmother sang in the choir at Haywood Street Methodist. But they had a set of abilities and skills. There were people in my family who could do hands-on healing, and my grandmother had precognitive dreams. She would wake up knowing what the dream had meant, but she never told anyone what the dream was because she was afraid if she did it would never come to her again.

Ballard's knitting needles softly clicked, providing a cadence to her melodic voice as she recalled a childhood steeped in love for the mountains, the abundant varieties of plants and wildlife and mythology. She took four years of Latin in high school and became the statewide expert in mythology when she was a teenager. She lived for a time in London and also in Texas when she was in graduate school, but she soon came home to the place she loves.

GRANOLA GHETTO

Dr. Milton Ready, a retired UNCA history professor, has witnessed the evolution of Asheville and chronicled its uniqueness in a variety of articles and books, including *Remembering Asheville*. Currently dividing his time between Landrum, South Carolina, and Wolf Laurel, North Carolina, he recently drove into Asheville on a brutally cold January day to discuss how Asheville has become known as one of the most interesting places on the planet.

"I have a name for Asheville—it's the 'Granola Ghetto,'" Ready said. "I use that term a lot. It's not as freaky as it once was in the '90s, but that freaky sort of culture—the Goth culture—is one of the keys to Asheville's charm and salability. I've had so many tell me that when they got off the plane and went into downtown Asheville, they would just hang around and that they never wanted to leave. Of course, it's thirty-five minutes from skiing and hiking, with all the mountains around, and people think it's a charming and manageable city."

In his article, "How Asheville Came to Be the Most Interesting Small City in America," Ready talks about how Asheville organically morphed into a place of peace, love and understanding following a long renaissance in the

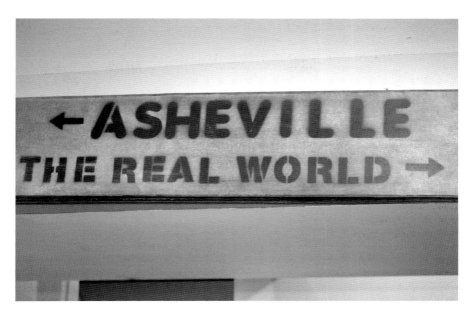

Sign hanging in Burgerworx in the Grove Arcade. *Photo by Marla Milling.*

Visitors find their way around town by taking a trolley tour. *Photo by Marla Milling.*

1980s. He says city leaders worked to revitalize downtown around "streetscapes, a downtown health adventure, a state-of-the-art theatre, museum, an urban trail, a restored Grove Arcade and a protected historic district."

Ready wrote, "For them, Asheville once again would become the cultural, artistic, crafts, literary, commercial, and political center of western North Carolina it had been in the 1920s, a tourist heaven but assuredly not the new freak capital of the nation. Asheville's visionaries did not foresee a born-again hippie culture that resembled that of the 1960s, only with more pierced body parts and less political angst."

He's enjoyed watching Asheville evolve over the years and said, "I think it's a wonderful street show." Change, however, is constant, and Asheville will continue to expand and grapple with new joys and new headaches along the way.

"The old Asheville was a fun city, unpolluted, un-congested, with no traffic problems. This is the new Asheville. I do think Asheville is at another one of those turning points. Affordable housing is one of the keys to the future," said Ready. "The Vanderbilts, the Coxes and the Groves are gone in Asheville. Now you have middle-class, a little older, semi-retired people coming here, and Asheville's future is tied more to them than the schemers and dreamers who built giant hotels and grand houses."

Younger people are also flocking to town, as today's Asheville attracts a hipper crowd along with young families looking for a great community in which to raise their kids.

MEN WHO LEFT A LASTING LEGACY

When George Willis Pack gave money for a library, he specified it must be open to all people. I truly think that set a tone for what Asheville has always been.
—Grace Pless, downtown development volunteer and
coordinator of the Urban Trail

When people asked me where I would start—what year I would begin writing about just what makes Asheville quirky and unique—I soon realized it is a question that defies time. There's no one year or generation that made Asheville a place unlike any other. It's much larger than that. This is reinforced by Joshua Warren's theory of Asheville being on a vast alignment with the unexplainable. There's something about this place that's always had a weird vibe, a creative draw and a spiritual resonance.

The vibe was here when American Indians roamed the land. It was present when settlers, predominantly Scotch-Irish immigrants, braved the harsh mountain environment to build lives here. And the energy was palpable when the railroad was established in 1880, opening Asheville up to the rest of the world—most notably wealthy people, who sought out Asheville for its clean air, healthy living and noted treatment for tuberculosis. Asheville was known as a center for tuberculosis care, with as many as twenty specialists, including Dr. Karl Von Ruck, and twenty-five sanitariums by 1930. When the railroad opened, Asheville's population was just over 2,600 people. By 1900, it had almost quadrupled, registering 10,235 residents.

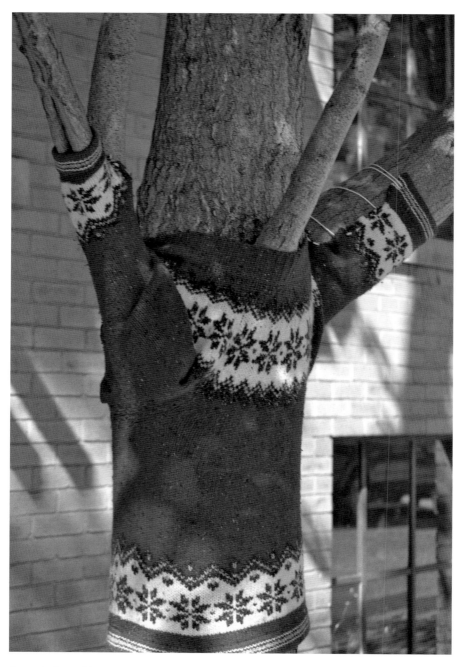

A tree is dressed in a sweater during a yarn bombing on Wall Street in October 2014. *Photo by Marla Milling.*

Vanderbilt's Influence

Hearing word spread through the grapevine in the late 1880s that a man with wads of cash was buying hundreds of acres of land with plans to build a castle must have seemed greatly exaggerated at best. That generation didn't have the benefit of the Internet and social media to spread news, so word traveled mouth to mouth and may have grown stranger in the telling.

The rich guy, George Vanderbilt, came into town in 1888 with his mother, Maria. She suffered from chronic malaria, and Vanderbilt also worried about the threat of tuberculosis. The fact that Asheville was not only beautiful but also touted for its healthy climate certainly grabbed his attention.

Surveying the blue-clad mountains from his vantage point on porch of the original Battery Park Hotel, opened by Colonel Frank Coxe in 1886, Vanderbilt concocted a magnificent plan to build a palace here. He snapped up 125,000 acres and hired a world-class staff to construct his dream home, which took five years to build. No other private residence in America has ever topped its square footage.

While he certainly felt the power that great wealth can provide, he also revealed a great conscience. It doesn't seem that he built such a grand estate

George Vanderbilt's gargantuan castle, the Biltmore House. *Ewart Ball Collection #N1023, D. Hiden Ramsey Library Special Collections, University of North Carolina–Asheville.*

to be a showoff or simply to entertain his own ego. In everything he did in creating Biltmore, he brought the best and finest to the Western North Carolina region. This included top artisans and architects who also left their majestic touches on buildings and homes throughout Asheville; the establishment of the Cradle of Forestry in America, with careful land-use practices and an eye for conservation and responsible stewardship; and also the creation of a self-sustaining estate with state-of-the-art farm equipment, the best breeds in livestock and modern techniques to promote a healthy harvest. He found a beautiful spot on the planet and had an out-of-the-box approach to making it even better.

"George Vanderbilt's farm was clearly cutting edge," said Ted Katsigianis, vice-president of agriculture and environmental sciences at Biltmore Estate. "That's one of Vanderbilt's greatest contributions to Western North Carolina—bringing high-tech agriculture here."

"If you'd been living here in the 1890s when George Vanderbilt brought all these foreigners in from Europe, speaking all these different languages, and started building this unimaginable, fantastic place in the middle of nowhere, that would have seemed almost supernatural from a rugged, rural frontier person's perspective," noted Warren.

Famous guests at the Grove Park Inn. *From left to right*: Harvey Firestone Sr., Thomas Edison, Harvey Firestone Jr., Horatio Seymour, Henry Ford and Fred Seely, son-in-law of E.W. Grove. *Omni Grove Park Inn*.

"That was the start of the strange mystique here," he continued. "Over the years, we have all these unusual, eccentric people come here. I mean, just look at the roster at the Grove Park Inn. You have Harry Houdini; Thomas Edison, who also was very interested in communicating with the dead; General Pershing, who was the most decorated military man in the history of the United States with the possible exception of George Washington— people who have these dramatic stories and backgrounds. That started creating this persona of mystery and the sensational around here."

GROVE'S LEGACY

It's comical today to look at the unusual advertisement E.W. Grove used to market the product that made him a fortune. The ad features a baby's face on a pig's body with the words, "Makes Children and Adults as Fat as Pigs" emblazoned on the pig's body. At the bottom, it reads "Grove's Tasteless Chill Tonic on the market over 20 years, 1 1/2 million bottles sold last year."

He promoted the tonic as a preventative for malaria and also as treatment for its symptoms. It flew off the shelves, surpassing the number of bottles of Coca-Cola sold in 1890:

> *I had a little drug business in Paris, Tennessee, just barely making a living, when I got up a real invention, tasteless quinine. As a poor man and a poor boy, I conceived the idea that whoever could produce a tasteless chill tonic, his fortune was made.*

His eyes first discerned Asheville's landscape when he arrived in 1897. The town's reputation as a health resort caught his attention at a time when bronchitis and chronic hiccoughs plagued him. He wound up staying and pumping a ton of money into property and then transforming it into some of the most treasured buildings in Asheville's history: the Grove Park Inn, located just north of town, and the Grove Arcade, a public marketplace in a prominent downtown location. Grove ultimately became dubbed the "Father of Modern Asheville," as he, like Vanderbilt, marked the landscape with his name and his fortune.

Grove's land grab included property on Sunset Mountain, where the Grove Park Inn stands today, as well as the land he transformed into his Kimberly Avenue and Grove Park neighborhood developments. Grove envisioned a

grand resort and entrusted his son-in-law, Fred Seely, with designing the grand inn and overseeing its construction. It took four hundred men working ten-hour shifts six days a week, but Seely managed to keep his promise that it would open for business one year from the groundbreaking. Secretary of State William Jennings Bryan gave the keynote address when the Grove Park Inn officially opened on July 12, 1913, saying that the Grove Park Inn "was built for the ages."

Grove also made his move into downtown, but change can be uncomfortable. Every generation, prior and since, in Asheville has some who lament the "good old days." No doubt they were feeling a lot of regret when they witnessed Grove order the demolition of the grand Battery Park Hotel, originally built in 1886 by Colonel Frank Coxe. The Queen Anne–style hotel served as a social center and welcomed the hoards of tourists flocking to Asheville after the railroad came through. He built another Battery Park Hotel in 1924—it remains standing today—and he leveled the hill that the original hotel sat on in order to encourage expansion of the downtown area. Crews carted the hillside away load by load. By an account in the *Asheville Citizen-Times*, the original hotel was built on the site of a Civil War battery. The hill rose eighty feet above Haywood Street.

According to Warren, Grove also championed for a subway system in Asheville. "There's an old tunnel system underneath Asheville," explained Warren. "When you look back and see pictures of all these old trolley cars, they were considered a nuisance at the time because the streets were packed with people. Moving that underground was part of the aesthetic philosophy of the modern era that people like Grove were trying to usher in."

That idea didn't reach fruition. Grove also didn't live to see the Grove Arcade completed, which he imagined as "the most elegant building in America." He died in 1927, and the Grove Arcade, with its massive 269,000 square feet of space, opened in 1929. It served as a bustling city market with fruit stands, candy and cigar stores, beauty parlors and barbershops, a haberdashery and other stores and offices.

The most tragic time in the building's history came during World War II, when the federal government took over the building, evicting the shops and offices with less than a month's notice. After the war, the elegant building became home to the National Climatic Data Center. It took decades before the Grove Arcade was restored and reopened in 2002 as the place Grove envisioned—a lively city market supporting a vibrant downtown.

GEORGE PACK

Recently I was walking through the hallway that leads from the Civic Center deck to Haywood Street. This hallway passes right by Pack Memorial Library. On this day, as I walked through, a group of people was in front of me. One of the men asked, "Is this Pack Library?" One of the women said, "Well, it's the library, but I don't know why it would be called Pack since it's not on Pack Square."

Given a little more time and courage, I would have interrupted their conversation to explain George Pack's impact on Asheville, how Pack Memorial Library was once on Pack Square and how his name represents a legacy of generosity to Asheville and its people.

Pack made his fortune through lumber manufacturing and sales. In his career, he worked with large lumbering companies in Michigan and Ohio. He and his wife moved to Asheville in 1885, and through their love for the place, they left a lasting imprint through very generous donations. Among the gifts included a building, once known as First National Bank building on Pack Square, for the creation of a library; property for Montford Park; a thirteen-acre piece of property designated as Aston Park; the "Sarah Garrison Kindergarten" on East Street; and a three-acre piece of property on College Street on which a building was erected that served as the Buncombe County Courthouse from 1901 to 1928. The Packs also contributed greatly to the Vance monument, which stands on Pack Square, as well as made donations to Mission Hospital and the YMCA, among others.

Pack did all he could to help improve the lives of everyone in Asheville. A February 16, 1895 issue of the *Asheville News and Hotel Reporter* noted: "The cold weather has caused a great deal of suffering among the poor of Asheville. Mr. Geo. W. Pack evidently had this in mind when he sent the following dispatch to Mayor Patton: 'Do your citizens need help on account of severe weather? If so, draw on me for such amount as you think proper.'"

In 1983, the *Asheville Citizen-Times* noted this in praise of Pack's contributions: "So when you next stand at Pack Square, read a book at Pack Memorial Library, or take a stroll through one of his many parks, take a few moments to remember this generous soul who did so much to make the city what it is today."

RAFAEL GUASTAVINO

It was George Vanderbilt who first lured Spanish architect Rafael Guastavino to Asheville. Guastavino had moved from Spain to New York City in 1882, and by 1894, he and his son reportedly had a monopoly on tile-vault construction in the United States. Their company created about one thousand buildings, including the Smithsonian Institution, Metropolitan Museum of Art, New York Public Library and the vaulted arches in New York City's Central Station.

When Vanderbilt sought out the best artisans in the world, Guastavino was a natural pick. His work at Biltmore can be witnessed in the arches and domes enclosing the Palm Court on the main floor of the house. He used a method developed in Spain called the Catalan structural system. This utilizes layers of tiles tied together with mortar to create surprisingly thin yet super-strong arched spaces or vaults.

When Guastavino arrived in Asheville in the 1880s, he fell in love with the beauty of the area and decided, as many do, to relocate on a permanent basis. He moved his beloved wife, Frances, to property near Black Mountain, where they lived in a place dubbed by mountain people as the "Spanish Castle" amid one thousand acres of land. Today, it's the site of Christmount camp.

He's most revered in Asheville for building the Basilica of Saint Lawrence, which sits across from the U.S. Cellular Center today. He and his wife were deeply religious, and after attending a crowded service at St. Lawrence Catholic Church, he offered to build, and help pay for, a new church in order to make room for many more worshipers. Completed in 1905, the entire structure was crafted from tile and similar materials on a granite foundation. The building is completely free of wood beams or steel. The roof is made of tile covered with copper.

Guastavino died suddenly in 1908 at the age of sixty-five—some claimed that he simply worked himself to death. He's entombed in a crypt in the basilica. There was a clock on the steeple of the Guastavinos' house, and when he died, Frances stopped the clock to the hour of his passing. It remained stationary for almost forty years.

From 1908 to 1943, Frances became a recluse in the house. The *Asheville Citizen-Times* reported, "It is said she set a plate at her deceased husband's chair each night for the evening meal, sometimes telling a man servant that her husband may come back someday." When she moved to a nursing home in 1943, vandals ransacked the property, and the missing items included

some of the remains of Guastavino's ancestors that had been kept in a bone room. A newspaper account reported, "Vandals tore open the boxes and stole the skulls, leaving the bones strewn through the house."

BUILDING BOOM OF THE 1920s

Say the name "Douglas Ellington," and there will be nods of recognition around Asheville. The Ellington name is intertwined with some of Asheville's most recognized architectural treasures. He's the creative genius who designed the Asheville City Building, the delicious pink tile–topped Art Deco masterpiece built in 1926, as well as First Baptist Church (1927), the three-story S&W Cafeteria (1929) and Asheville High School.

It's disappointing that county leaders in the 1920s opted to go with a different architectural firm to build the courthouse beside the City Building. Ellington had designs for a matching courthouse, but the politics of the day granted the project to a firm out of Washington, D.C. The courthouse,

Architect Douglas Ellington suffered a deep hurt when leaders of the day rejected a plan to build a courthouse that matched the elegant style of the Asheville City Building. The austere courthouse sits today beside Ellington's pink-topped Art Deco city building. *Photo by Marla Milling.*

completed in 1928, looks mismatched next to the city hall, its austere exterior looking a bit homely compared with the elegance of its companion.

In an oral history (archived at the D.H. Ramsey Library at UNCA) with famed Asheville wildlife artist Sallie Ellington Middleton, she speaks of the deep hurt that Ellington suffered when his concept for the courthouse was rejected. According to her account, town leaders didn't tell Ellington about their plan to use another firm for the courthouse design. He read about it in the newspaper. Middleton said this was a "bad hurt" that "wounded Douglas for life. He never spoke of it—no one mentioned it."

More than sixty-five buildings were created in the building boom of the 1920s. Notable mentions include the fifteen-story Jackson Building (1924), the first skyscraper in WNC and a structure recognized for its slender footprint and architectural details, including the gargoyles hanging over the sides near the top; the Flat Iron Building (1926); and the Kress Building (1928).

Other significant downtown buildings that came on the scene in later decades include the BB&T Building (1964) and the building on Pack Square created in the late '70s by famed architect I.M. Pei. He's known as the designer of the National Gallery of Art in D.C. and the Pyramids of the Louvre in Paris. A block of historic buildings came down in the spot where the Pei building stands today. It was originally built to serve as the headquarters of the Akzona Corporation, and some locals still refer to it as the Akzona Building. Others refer to it as the Biltmore Building since it houses the executive and professional offices of Biltmore Estate.

The modern building has mirrored walls, which reflect the historic buildings around it. Take a look the next time you're on the square, and you'll see the Jackson Building, Legal Building and other buildings reflected in the walls of the Pei building.

THE INFLUENCE OF WOMEN

I don't think Edith Vanderbilt is acknowledged enough for her work in preserving Biltmore.
—Darren Poupore, chief curator, Biltmore Estate

While the previous chapter emphasized the contributions of men, there have been plenty of strong, enterprising women through the generations who have also left their mark on Asheville. Edith Vanderbilt, for one, took over running Biltmore Estate after her husband's untimely death in 1914. While she had wealth and status, she still had to dig deep into her strength and courage to meet the growing demands of running the estate.

"Edith had an unfortunate childhood," explained Darren Poupore, chief curator at Biltmore Estate. "Both of her parents died from illness when she was a child. She and her siblings lived with their grandparents in Newport, Rhode Island. After their grandparents passed away, they were raised by a governess in Paris. I think it made her very strong and served her well when she lost her husband. George Vanderbilt is talked about as owner and creator of Biltmore, but I think we have Edith to thank for Biltmore surviving and her role in making sure Biltmore was preserved."

Mrs. Vanderbilt was known as a very kind, compassionate woman who took gift baskets to estate workers when they were celebrating a birth or struggling with illness or other hardship. She also held jobs for members of her staff who went into the military during the war. One British butler

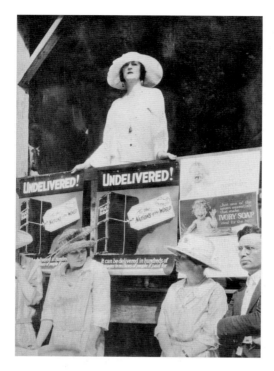

Edith Vanderbilt is shown here welcoming several hundred Community Night School members at Biltmore Estate on June 24, 1923. *North Carolina Collection, Pack Memorial Library, Asheville, North Carolina.*

asked to return to his home country in World War I to join the effort. When he got out, Mrs. Vanderbilt welcomed him back. He was a highly decorated soldier and had lost a hand in the war. Poupore said that he continued to work at Biltmore until 1940.

Edith also concentrated on continuing what her husband started with scientific farming and forestry. She became the first female president of the North Carolina State Fair and was such a force in promoting improvement of agricultural procedures across the state that the state legislature invited her to address it in a joint session. Another notable act included fulfilling her husband's wishes to sell land to the government that ultimately became the Pisgah National Forest.

JULIA WOLFE

Thomas Wolfe's mother had a strong entrepreneurial spirit and a wealth of inner strength. She endured a great deal of scrutiny in her life—first in her savvy business dealings and second in having her family life revealed in the pages of her son's novel *Look Homeward, Angel.*

"The sad part of it all is that a woman in that time period who didn't follow the accepted norm of a Victorian housewife was considered somewhat unusual. As a result, she was considered a little queer and a bit isolated in her community. It just wasn't usual for a woman to be that involved in business," said Tom Muir, manager of the Thomas Wolfe Memorial.

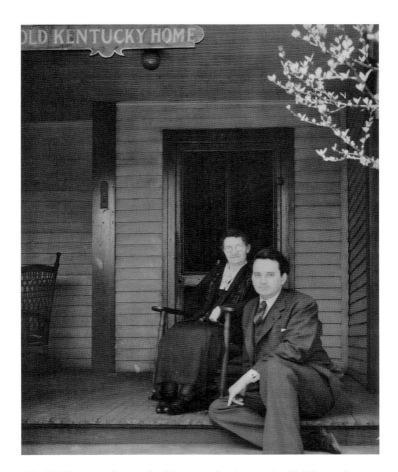

Julia Wolfe sits on the porch of her boardinghouse, the Old Kentucky Home, with her author son, Thomas Wolfe. *Thomas Wolfe Collection, Pack Memorial Public Library, Asheville, North Carolina.*

Along with opening the Old Kentucky Home as a boardinghouse at a time when Asheville had about eighty boardinghouses, she also had quite a number of real estate investments in the Asheville/Buncombe County area, as well as holdings in Florida. "Thomas Wolfe wrote that his mother looked at Asheville like a map. She would study traffic patterns in town to see where people were going. She'd say, 'There's going to be a street through here someday so we should own this lot,'" said Muir.

"She certainly was actively involved in property in Asheville and had a number of rental incomes," he added. "I'm sure she would be fascinated today with who is buying and selling properties and how Asheville is growing.

She would probably be a little disappointed that Asheville still hasn't reached the size that had been predicted in the 1920s. They were thinking in the boom times that Asheville would reach a population of 100,000 by 1930. The stock market crash and Depression certainly set the city way back from what the early predictions were."

OPENING BILTMORE TO THE PUBLIC

Ownership of Biltmore Estate transferred to the Vanderbilts' only daughter, Cornelia, when she turned twenty-five. She and her husband, John Francis Amherst Cecil, made a big decision in the Depression years to help Asheville increase tourism, as well as help the estate. Growing costs were making it a struggle to run, so they agreed to open Biltmore House to the public for a two-dollar admission fee. They made the public announcement on March 15, 1930. It followed with Vanderbilt's idea of making the land accessible to the public.

"Mr. Vanderbilt allowed passes to drive through the estate," said Poupore. "There was always a sense that the estate was meant in some degree for the public, but he was also very private and never opened the house to the public while he lived there."

Just a few years after the Cecils opened Biltmore House, they divorced, and Cornelia left her father's home for Europe. She never returned.

THE aSHEville MUSEUM

In true Asheville fashion, there's a new museum devoted to "her" story. Mother-daughter team Heidi Swann and Gems Ouizad co-founded aSHEville Museum in July 2014 in a sweet space on Wall Street. They have inspiring exhibits about Asheville women, as well as women from around the world. A gift shop in front offers a colorful assortment of jewelry, scarves and other items from more than thirty local women, as well as fair trade items and fun, funky boutique items.

"We don't know of many places like this—in the whole world there's only about sixty women's museums, and in the United States there are just a handful," said Swann.

One of the Asheville women highlighted in the current exhibit is Thelma Caldwell, an African American woman who came to Asheville in the 1960s to serve as head of the Phyllis Wheatley branch of the YWCA. She ultimately became executive director of the integrated Asheville YWCA, making her the first African American Y director in the South and just the second one in the United States. Under her leadership, the segregated branches of the Y merged permanently in 1970. Caldwell's work in a very challenging era helped Asheville become the inclusive, diverse place it is today.

Another prominent Asheville woman at the aSHEville Museum is Asheville native Wilma Dykeman. She's well known for her books *The French Broad*, *Return the Innocent Earth* and *The Tall Woman*. Her work promoting and urging protection for the French Broad River led to creation of the Wilma Dykeman RiverWay Plan. It's a seventeen-mile greenway tying together the French Broad and Swannanoa Rivers.

"I think we add to the cultural landscape of downtown, of Asheville in general, by adding another offering to guests that's educational and hopefully inspiring and insightful," said Swann. "We want to take people on a journey—a journey through history, humor and back into more challenging subjects and then on to inspiration and hope and a call to action."

A ROCKY FIFTY YEARS

1929–1979

Thomas Wolfe no doubt put Asheville on the map very early on as a destination for creative people. We see scores and scores of writers today who found an early inspiration in their youth by reading his works. Last year, we put twelve new rocking chairs on the front porch of [the Old Kentucky Home]. *Each one was sponsored by a North Carolina writer in honor of Thomas Wolfe.*
—Tom Muir, historic site manager, Thomas Wolfe Memorial

Two events significantly rocked Asheville's residents in October 1929. Thomas Wolfe's blockbuster novel *Look Homeward, Angel* appeared in print on October 18, 1929. Eleven days later, the stock market crashed, leading into the Great Depression.

Sold as fiction, Wolfe's book was a thinly veiled autobiographical account of his life growing up in Asheville, which he called Altamont in his novel. The fictional Gant family was easily identified as members of his family, and other characters were also pinpointed as town residents or boarders who lived at his mother's boardinghouse.

"Most good 'Christians' in this town hated his guts because he showed them for what they were—a bunch of hypocrites," said Pat McAfee, author, poet, retired high school English/drama teacher and former owner of the Ancient Page Bookstore in Asheville. "No one likes to have their underwear exposed, so to speak, and he exposed it. I like that about him."

Threats that he would be tarred and feathered if he ever returned to town kept Wolfe away until 1937. By that time, the anger had faded, and most

Author Thomas Wolfe poses with boarders staying at his mother's boardinghouse. *Thomas Wolfe Collection, Pack Memorial Library, Asheville, North Carolina.*

people in Asheville embraced him as a famous author and welcomed him home. It's said that the only people who harbored a grudge at this point were the people who *couldn't* recognize themselves in the book.

I grew up hearing about Wolfe from my grandmother Lucile Chandley Midyette Hardee. She was a classmate of Wolfe's sister, Mabel, and she knew the family well. Before she died, she told me she had been with a group of friends invited to visit with Wolfe at the Oteen cabin he rented during his return in 1937. As the gathering broke up, Wolfe asked Lucy to drive him into Asheville so he could see his mother. But before they arrived, he said he wanted to go see Pearlie first. Pearl Goode Chandley was Lucy's mother and my great-grandmother.

Pearl ushered them into a Sunday evening dinner of fried chicken and all the fixings. My dad, who was just a boy at the time, remembers this tall stranger because he ate all the potato salad—my dad's favorite food at the time. I love the connection with Wolfe and the fact that he knew my family. Asheville was a much smaller town then, with everyone knowing everyone else.

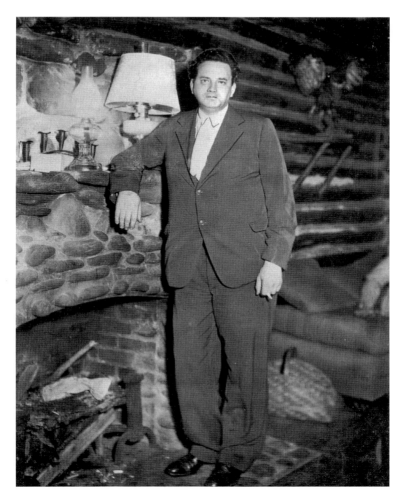

When author Thomas Wolfe returned to Asheville for a visit in 1937, he stayed at a cabin in Oteen. *Thomas Wolfe Collection, Pack Memorial Library, Asheville, North Carolina.*

Robert Bunn, who owned an antique store on Biltmore Avenue, told me in an interview before his death that he was a childhood friend of Wolfe and that one of their hangouts was Goode's Drug Store. That store was owned and operated by my great-uncle (Pearl's brother), John Goode.

Today, Wolfe is revered as a favorite son of Asheville. His mother's boardinghouse, known as the Old Kentucky Home, was almost lost on July 24, 1998, when an arsonist torched the rambling structure. It underwent a $2.4 million renovation and reopened in May 2004.

Goode's Drug Store when it was located on Haywood Street next to Woolworth's. *North Carolina Collection, Pack Memorial Library, Asheville, North Carolina.*

Current Asheville city councilman Jan Davis said that he always advises newcomers to read a copy of Wolfe's book if they want to understand Asheville and get a perspective of what it was like in his time. Davis is an Asheville native and owner of Jan Davis Tire Store on Patton Avenue. He grew up in West Asheville and has worked his entire adult life downtown. He's also put a lot of energy and devotion into promoting its positive growth.

"Most of us are of Scotch-Irish descent, as Thomas Wolfe was," said Davis. "His mother, Julia, was a Westall and very proud of it. Even back in those years, people came here as a tourist destination and stayed in places like the Old Kentucky Home. It's always had a tourism flair and always attracted a quirky sort of people—writers like Hemingway. He didn't spend tons of time here, but he was here. And then there's F. Scott Fitzgerald, who spent a lot of time here, and his wife, Zelda, who died here, and O. Henry, who is buried here."

As Davis mentioned, one chapter of Asheville's unique history that continues to leave locals and tourists spellbound is the connection with F. Scott Fitzgerald and his wife, Zelda. There's also great sadness connected with their time in Asheville. Fitzgerald spent two summers at the Grove Park Inn, where he attempted to write salable material, but in Tony Buttita's book *After the Good Gay Times,* he noted that Fitzgerald was filling trashcans with empty beer bottles and wadded up pages more than he was turning out useable text.

Sadder still was the fate of Zelda, who spent time battling mental problems at Highland Hospital in Asheville. She died in a fire on the night of March 10, 1948, along with eight other women.

PAYING OFF THE DEBT

The tough Depression years hit Asheville hard, but it left the town with its priceless architectural structures safe from the wrecking ball. Following the opulent building boom of the '20s, Asheville reportedly had more debt per capita than any other city in the nation. City leaders made a vow in the '30s to pay back every cent of the debt. This was a key move in leaving Asheville with architectural treasures today. The city simply couldn't afford the urban renewal that was taking place in other towns in the 1950s and '60s. The debt was officially repaid in 1976, and city officials held a public ceremony to burn the bond notes.

Walking around downtown Asheville is much like walking through a time capsule, with its preservation of vintage buildings. The opulence of the Roaring Twenties sets the stage with the city's preserved buildings and adds to the charm visitors experience today.

DOWNTOWN OF THE '50S, '60S AND EARLY '70S

Many people who wax nostalgic about the way Asheville used to be often focus on the 1950s and '60s. It's a period when Asheville drew in a steady stream of people who shopped at the big department stores, including Bon Marché, Ivey's, Sears, Penney's and Winner's. There was also a healthy assortment of smaller stores, restaurants and businesses, and even many of the doctor and dentist offices were downtown.

Asheville native Jan Schochet grew up in a family of downtown business owners. Her father's older brother owned the Star Store, which sold a wide variety of items from army/navy clothing and supplies to pup tents, army blankets, Levi's cowboy boots and leather jackets with long fringe.

After World War II, when Schochet's parents were trying to figure out what to do, he convinced them to open their own business at 9 Patton Avenue. They started the Bootery in 1944. The next year, the owners of

Bon Marché originally occupied the building at the corner of Haywood Street and Battery Park Avenue that now serves as home to the Haywood Park Hotel. *Ewart Ball Collection #N1521, D.Hiden Ramsey Library Special Collections, University of North Carolina–Asheville.*

Fletcher's School of Dance approached them and asked if they could sell dance shoes and dance wear to meet their students' needs. They added the dance inventory in 1945.

In 1964, when the BB&T Building was going to be built, Jan's parents had the opportunity to buy space at 16 Patton Avenue. They combined stores with Schochet's uncle. He ran the Star on the left side, and her parents ran the Bootery on the right side. When Schochet's uncle died in 1971, her parents combined the two stores. Customers started referring to it as the Star Bootery, and it eventually took that name officially.

Around 1975, Schochet's dad bought space at 14 Patton Avenue. He didn't have any plans for it. He had just heard through the grapevine that it was targeted to be a rummage sale space, like those at the time on Lexington Avenue, and he didn't think that would be so good for his business. In 1978, the family developed a plan on how to utilize the space. Schochet was in graduate school in New York and lamenting to her mother about the

difficulty of finding a career in her field. Her mother suggested returning to Asheville, taking their dancewear inventory out of the Star Bootery and opening a store in the vacant space they owned next door.

"I was around twenty-five years old and had total free rein over the title, the logo, the décor, everything," said Schochet. She opened A Dancer's Place in August 1978 and ran it until 1987. The family sold the business in 2006, but Schochet continues to own and manage the properties at 14 and 16 Patton Avenue.

She's devoted to historic preservation and was an active opponent to the 1980 plan to build a mall in Asheville (more on that effort in the next chapter). "I was just blown away by the Strouse Greenberg mall plan," said Schochet. "To me, malls were the enemy. It's what destroyed Asheville and every other downtown. I could not understand why people didn't understand that we had wonderful old buildings, so I started going to the meetings and [was] really glad to be part of the [Save Downtown Asheville] organization."

THE FAMILY STORE

She's also devoted to preserving the rich history of Jewish merchants who helped shape Asheville. Schochet holds a master's degree in folklore and teamed up with Sharon Fahrer in 2001 to create a history consulting firm called History@Hand. From 2002 to 2005, they interviewed and recorded the oral histories of many Jewish family members who had operated businesses downtown or had parents and/or grandparents who were Asheville business owners.

This project, called "The Family Store: A History of Jewish Businesses, 1880–1990," features a twelve-panel exhibit that originally appeared around town in the fall of 2006 and 2007. It's archived in the Special Collections at D.H. Ramsey Library on the UNCA campus.

"It's my goal to get it back up all over downtown again," said Schochet. "Think about how many people have moved there since we first put it up. It's a hidden history. A forgotten history. So many of the businesses were owned by Jewish people and many of the restaurants owned by Greek people. It was like a 'family and friends' kind of downtown."

An excerpt from the program flyer notes that "it showcases a time when all downtowns were destinations of purpose, providing the items necessary for daily life, from groceries to clothing to restaurants. During the majority

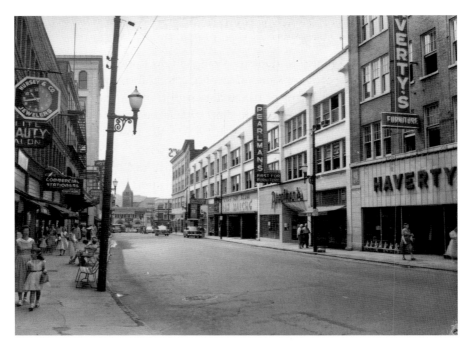

A view of Haywood Street looking south toward the S&W Cafeteria building. This photo was taken in the 1950s at a time when Jewish families owned a vast majority of downtown stores. *North Carolina Collection, Pack Memorial Library, Asheville, North Carolina.*

of this period, downtown Asheville was the shopping hub of Western North Carolina. These merchants (more than 435) laid the groundwork, both physical and commercial, for downtown Asheville to be the arts and tourism destination it is today."

The "Family Store" project documents businesses in a core area, which includes certain blocks of Broadway, Biltmore, Patton and Lexington Avenues; Haywood and College Streets; and Pack Square. It's amazing to look through the exhibit and see the wealth of Jewish-owned businesses, including Bon Marché, which three generations of the Lipinsky family operated for more than ninety years; Winner's; Pearlman's Super Furniture Store; Vogue Furriers; Cancellation Shoes; IXL Store; Lee's Jewelers; Tops for Shoes; the Imperial Theatre; the Man Store; Artmore Furniture Company; and Asheville Showcase. The list goes on and on and on.

FLIGHT TO THE MALL

The Asheville Mall opened its doors in 1973, and downtown Asheville began a quick descent. Department stores that once filled downtown buildings left for new digs at the mall. Many of the smaller stores left in the downtown area closed due to lack of traffic, and some shop owners who were old enough just decided to retire instead of trying to move. Others, like downtown staple Tops for Shoes, persevered and kept their downtown presence.

The next year, Asheville built a new civic center, and leaders hoped that it would keep people coming to the downtown area. Bob Hope was the opening act. In 1975, Elvis Presley gyrated on the civic center stage during a three-night run. In 1977, Elvis was due to play a sold-out show at the Asheville Civic Center on August 26, 1977, but tragically died on August 16, the day before he was set to leave on his cross-country tour.

By 1979, Asheville's streets were quiet. There were more boarded-up storefronts than those operational, and the flow of people wanting or needing to come downtown had significantly dried up. That year, organizers created the Bele Chere festival, hoping that it would rejuvenate interest in downtown. The first year was scant, with just a few booths occupying a few blocks on Haywood Street. The seeds, however, were set, and each year Bele Chere got a little bigger and began expanding gradually to cover more streets. It became known as the largest street festival in the Southeast, with 300,000 or so people attending over its yearly three-day run at the end of July.

Spotting the strange, weird and even taboo became customary at Bele Chere. In later years, random women would walk through town topless; on the other side of the spectrum, street preachers would use megaphones and microphones to blast their condemnation and predictions of doom to unbelievers. In the middle of those two extremes, Bele Chere offered a wide mix of music, booths overflowing with arts and crafts, lots of food and drink and an abundance of unusual and quirky people-watching opportunities.

By the time the plug was pulled on Bele Chere in 2013 after a thirty-five-year run, there was no longer a problem of getting people to the downtown area. The festival had served its purpose and contributed to the town's appeal.

Of course, even without Bele Chere, there are still fun festivals and gatherings throughout the year. Downtown After 5, led by the Asheville Downtown Association, brings out a lively crowd to a stage set up at the end of Lexington Avenue on select Fridays in the summer. There's also the

Left: Crowds line the downtown streets during the Bele Chere festival, which ran each July from 1979 to 2013. *Photo by Zen Sutherland.*

Below: A lively Friday night in Pritchard Park at the drum circle. *ExploreAsheville.com.*

Opposite, bottom: The Asheville Mardi Gras Parade leaves a trail of beads and smiles in downtown, 2015. *Photo by Marla Milling.*

The Asheville Tourists baseball team plays at McCormick Field, and the mascots, Ted E. Tourist and Mr. Moon, keep the crowds happy. *Asheville Tourists*.

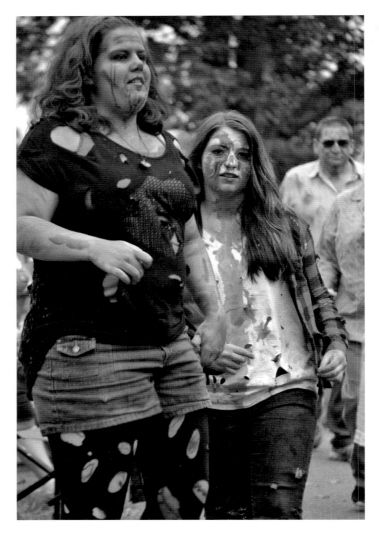

You never know what you might encounter in Asheville, especially when it's time for the annual Asheville Zombiewalk. *Photo by Marla Milling.*

drum circle, the Lexington Avenue Arts and Fun Festival (LAAFF), LEAF, Big Love, Big Crafty, Asheville Zombiewalk, Asheville Mardi Gras events, Shindig on the Green, watching the Asheville Tourists play home games at McCormick Field and other fun happenings.

SAVE DOWNTOWN ASHEVILLE

As we looked at it, it looked like a spaceship that had landed in downtown Asheville.
—Bob Gunn, design architect, talking about plans he worked on
for a proposed downtown mall in the early 1980s

Asheville came close to losing much of its unique character in the early 1980s, but thanks to a self-proclaimed "ragtag bunch," more than eighty-five buildings slated for destruction remain standing today. This counterculture revolution of business owners and concerned citizens against the status quo of local government seemed impossible at times, but their passion paved the way for Asheville to retain its history and emerge as a town highly recognized for its stunning uniqueness.

After the city paid off its pre-Depression debt in 1976, it created the Asheville Revitalization Commission (ARC) in August 1977 to help the downtown area create a comeback plan. In those days, Asheville had a ghost town quality to it, with many buildings boarded up and few people coming downtown unless they had an office or business there.

But the town wasn't dead. It still had a pulse, and many business owners worked steadily to find enterprising ways to rebuild. Most embraced a plan by the ARC for slow, responsible growth based on historic preservation, not historic destruction. They nodded with approval while watching developer John Lantzius steadily fulfill his vision of transforming Lexington Avenue's red-light district into a vibrant area featuring creative shops, restaurants and living space. He had a vision for injecting life into Lexington Avenue by

buying buildings and then keeping rent low enough to entice artists and other funky businesses to open.

Then developer Strouse Greenberg of Philadelphia galloped into town and cozied up to city officials, dazzling them with plans to resurrect the desolate downtown area by smashing up seventeen acres of buildings, carting off the debris and erecting a giant, impersonal, generic mall in its place. The proposed mall would have included 700,000 square feet of retail space to house three anchor stores and 110 shops, a 250- to 300-room convention hotel, office space totaling 125,000 square feet and 3,500 parking places located underneath.

The plan would have decimated Lantzius's work and vision, but the mall plan wasn't limited to leveling his buildings on Lexington Avenue. It also targeted structures on Walnut, Haywood, College and Broadway, among others. The Kress Building, noted as an Art Deco treasure, would also have been reduced to rubble.

Business partners Kathryn Long and her brother-in-law, Wayne Caldwell, heard the news about the planned mall from a friend who worked in the City Planning department. They had agreed with ARC's vision for responsible revitalization and reacted with stunned alarm about the plan for massive destruction.

Long's parents bought Sluder Furniture in 1964 and ran it on Broadway. It originally opened in 1905. Wayne also worked in the family business, and in 1977, they became partners in Ambiance Interiors. Originally located beside Sluder Furniture on Broadway, Ambiance Interiors now operates on Chestnut Street.

"Richard Thornton was a friend of ours," said Long. "He was seeing these plans and flow charts, and he was so shocked. Since he knew us, he sat us down and said, 'Look, guys, you're not going to believe this so I want to tell you that it's true. They are as serious as a heart attack about making this happen. They want to take your property by eminent domain and bulldoze it and build a suburban shopping mall.'"

"I moved back here about the time the open cut [through Beaucatcher Mountain] was happening, and the people who opposed that started way too late," explained Long. "Richard knew that if we didn't start early, immediately fighting this, that it would be lost. Contracts get made, good ol' boys make deals and that's how the open cut happened."

"The mall plan was publicly announced in mid-March 1980, and we organized Save Downtown Asheville either that week or the next," said Caldwell. "We started out being a pretty ragtag bunch. At that original

Downtown heroes Wayne Caldwell and Kathryn Long worked tirelessly to prevent downtown Asheville from being turned into a generic mall in the early 1980s. *Photo by Marla Milling.*

meeting, I remember looking around and thinking, 'We're never going to do this.'"

Right after they organized their grass-roots effort, city officials held a public hearing at city hall. A crowd showed up demanding answers, but Verl Emrick, City Planning director, carefully deflected questions about the timing of the project. "Verl said three or four times in that meeting that there was no timetable," said Caldwell. "He said, 'We don't know. It's just an idea.'"

That's when Kathryn Long stepped up to the microphone and unfurled a flow chart. "I said, 'According to this, demolition begins in September, and it's signed by your name, Mr. Verl Emrick,' Well, I was shaking like a leaf. I am not an actress, but I was told that he turned about as white as a piece of paper," said Long. "I rolled up the flow chart and said, 'I'm going straight to our attorney for Save Downtown Asheville.' I walked out the door. That was on two or three TV networks that evening. So it made the public aware that there's some scuttlebutt going on here, some dishonesty going on and [that] we better pay attention to this. I think it really got people mad."

Peggy Gardner heard through the grapevine about the proposed mall and accepted an invitation from a friend to go to a Save Downtown Asheville

meeting. An Asheville native, Gardner grew up helping out at her dad's store, Gardner's Shoes. Her grandfather once had a shoe shop where Lex 18 is now, and her dad's shop was on College Street before he moved to 32 Broadway. She felt protective of Asheville and its buildings and knew quickly that she wanted to be a part of the movement to stop the mall.

As she related her memories on a day in November 2014, she's seated in Strada Restaurant, housed in a building across the street from her dad's former shop. While her dad's shop was just outside the perimeter of the proposed mall, the building housing Strada would have been turned to dust. She remembered going there as a child to eat when it was Tingle's Café. Later, when the controversy was in full swing, it served as the location for Ambiance Interiors.

"It might have been upstairs in this building where the meeting was held," said Gardner. "I remember being in the back of the room and hearing them talk about a specific place and thinking, 'No, not that building, too.' That's when I started getting an idea of how big the scope was, and I had this visceral reaction to it. For some reason, I said, 'If people knew which buildings you were talking about, it would really help. They need to know in some visual fashion.' I think Wayne said, 'Can you put that together?'"

WRAPPING DOWNTOWN

Gardner, a UNCA senior at the time, didn't quite know what she'd do, but she felt invested in coming up with some way to help. Then she thought of the work of Christo, a Bulgarian artist known for his artistic wrapping of different objects.

She created a plan to wrap the seventeen-acre proposed site of the mall to let people see exactly which buildings could fall victim to a wrecking ball. A friend at the Slossmann Corporation agreed to donate recycled cloth for use in the wrapping, and Peggy got a permit for an "educational project" from the Asheville Police Department. It stated that the wrap could "remain in place long enough to be recorded by the news media."

Another step involved getting a map and measuring the blocks to know how much fabric would be needed to fully cover the targeted area. Gardner made an appointment to talk with City Planning director Verl Emrick. She had been told that she wouldn't be able to see anything. When she got to his

office, he wasn't there. The woman at the desk told her that she could go into his office and wait for him.

"I went in, and the plans were spread all over his office. I thought this was kind of fortunate," said Gardner. "So Verl walks in, and I said, 'I was told there weren't really any maps, but this is what I came for and I'd like these to be put up at the library.' I was being more nervy than I thought I had in me. He said, 'Okay.' I don't think he had a choice, really. So those plans went over to the library."

Gardner directed wrapping the proposed mall area in white cloth at 3:00 p.m. on Saturday, April 19, 1980. WLOS-TV aired it on its newscast, and the *Asheville Citizen-Times* featured it on the front page of the April 20 Sunday edition. The newspaper account noted, "The wrap…was accomplished by having 200 people man 160 stations around a two-mile area of downtown. Pieces of cloths were tied together and held aloft between the stations for 10 minutes—long enough for photographers to scramble around the wrap and record the event."

"We had the sense that if people know they will be concerned, and I think this was correct," said Gardner. "It was this huge, beautiful thing that worked for a brief period of time."

Volunteers hold up lengths of fabric used to wrap downtown. *North Carolina Collection, Pack Memorial Library, Asheville, North Carolina.*

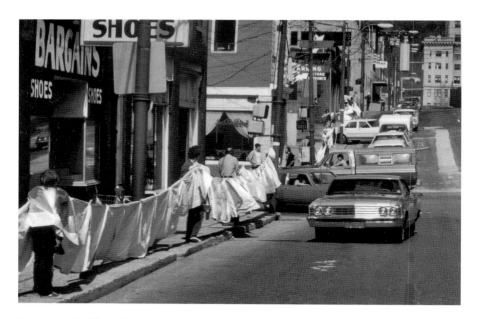

As part of the "Save Downtown Asheville" movement, two hundred volunteers hold up pieces of tied fabric to protest plans for a downtown mall. *North Carolina Collection, Pack Memorial Library, Asheville, North Carolina.*

A reporter for WLOS-TV interviews Peggy Gardner about the wrap she coordinated in downtown Asheville to draw attention to the eighty-five buildings targeted for demolition. *North Carolina Collection, Pack Memorial Library, Asheville, North Carolina.*

AN ECLECTIC HISTORY

Much of Asheville's history was at stake, and as the *Asheville Citizen* reported on March 19, 1980, "The area is part of a large portion of the downtown designated a historic district in the National Registry of Historic Places. It is considered valuable historically not for any singular landmarks, but for the area as a whole, which was a trade center for the city." But that historic designation didn't deter city officials from pushing forward. On November 11, 1980, the Asheville Planning and Zoning Commission ruled that the area proposed for the mall met the criteria for a blighted area under state urban renewal statutes. This was a key step for city officials to be able to buy the properties under eminent domain.

GROUP OF A THOUSAND

Meanwhile, Wayne Caldwell, serving as chairperson of Save Downtown Asheville, continued to rally members to keep applying pressure. They called themselves the Group of a Thousand.

"Do you know about Cinematique?" asked Kathryn Long. "We used to have these foreign films at Beaucatcher Theater. Apparently someone sitting in Cinematique one day looked around and said, 'Gosh, there must be five hundred of us in this theater today, and there will be five hundred showing up tomorrow. There must be one thousand of us coming to see this alternative theater.' So that's the Group of a Thousand, and a lot of those people are the ones who rose up and helped fight this."

Caldwell said that his family saw little of him during those days unless they were watching TV. He says he attended 95 percent of city council meetings for eighteen months. Save Downtown Asheville published a newspaper to educate the public about what was happening. It also created flyers and posters and looked for additional ways to engage the media in telling the story.

"There was a huge meeting at the Radisson, and we made a huge sign with big letters," said Long. "My mother and I worked on that. About the time the meeting started—and it was standing room only—we started unfurling this thing, and it went on for several yards. It said, 'GO HOME STROUSE GREENBERG,' so that was on the news. The people watching the news who weren't involved were seeing how much objection there was to the plan, and I think that kept rallying people even if they were staying at home. They were conscious of how much was going on."

At times, the battle seemed insurmountable, as they realized they were up against a lot of power and influence. As Caldwell said, "We expected we'd be fighting city council and the Merchant's Association, but it was also the banks, it was Carolina Power & Light and the hospital." He also said that there were three members of the revitalization commission who owned property in the district. "That always smelled really bad to me," he said, "and had we had to go to court, that conflict of interest would have been a big part of why we were in court, but fortunately we didn't have to do that."

"There were people that owned property that I think honestly did not see any other way," said Long. "They did not see the vision that it could be a wonderful place without tearing down the buildings. They thought, 'This is great. We can get rid of our property down there because it's not valuable at all.'"

The saving grace came down to how the project would be funded. The developer planned to invest $100 million in the project. The city would need to come up with $40 million for its part. But how? Leaders hoped for revenue bonds that they could push through, but decision makers in Raleigh said no. The only possibility then was general obligation bonds requiring voters to go to the polls in a referendum.

Save Downtown Asheville turned up the heat by distributing flyers with the heading, "The City Is Asking for Your Vote for $40,000,000.00 in Bonds on November 3. Here Are Some Facts You Should Know Before Voting." Residents already weary from the debt repayment that ended in 1976 were concerned and cautious about jumping back into a deficit.

LIVE TV DEBATE

To give residents even more information, WLOS-TV, the *Asheville Citizen-Times*, WWNC radio and WLOS-FM joined together to host a town hall meeting, which was held at First Baptist Church and aired live on WLOS on October 23, 1981.

Pro-mall panelists included Sister Mary Veronica Schumacher, CEO of St. Joseph's Hospital, and Walt Gladding, senior vice-president of NCNB bank in Asheville. Jim Daniels, ARC chairman, was their backup person for reference. On the anti-mall side, the panelists included Wayne Caldwell and attorney John Powell, with Save Downtown Asheville attorney Bob Long as the backup person.

"When Bob Long heard who would be on their panel, he just grinned and said, 'Man, this is going to be like shooting fish in a barrel,'" Caldwell remembered. "We practiced and we had makeup people," he said. "We also salted that audience with questions. Every hippie we could find had a little question in his pocket. We pretty much filled that auditorium…I remember meeting Walt Gladding on the street the week before, and he said, 'Have you all practiced?' I said, 'Nah.' I just lied to him. He said, 'We haven't either.' And as it turns out, they hadn't."

"Sister Mary Veronica didn't know anything about the project," said Kathryn Long. "They just thought if she showed up in a nun's habit, God would be on their side. I remember her having a very confused look on her face at more than one point. That's one of the most distinguishing memories I have about that debate. I watched from home because I was so exhausted I couldn't even go physically."

Her fatigue turned to jubilation a week and a half later, when voters went to the polls. Long remembered attending the party of her life when Save Downtown Asheville celebrated at Gatsby's on Walnut Street the evening of November 3, 1981. Voters had given a resounding "No" to the Strouse Greenberg mall. "It was 66 percent against the mall," said Long. "And North Asheville is about the only area of town that voted for it." The *Asheville Citizen* reported on November 4, 1981, that "voter traffic was heavy during most of the day—13,931 voters turned out, roughly 55 percent of the city's 25,067 registered voters."

What the Save Downtown Asheville organizers didn't know at the time is that some of the project architects were also pulling for a defeated referendum. "I was one of several architects at a firm called Dellinger & Lee who worked on the project," said Bob Gunn of Charlotte. "It's a tricky situation when you are working for a client, and they are paying you. We had done other suburban mall projects, but many of us didn't believe that a mall propped in the middle of a city is necessarily the right thing to do, especially in a city the scale of Asheville."

"We did a model of it that was essentially white plastic," he continued. "I built the model. It could have been more persuasive—let's put it that way. As we looked at it, it looked like a spaceship that had landed in downtown Asheville. It was like any other mall except it sat on top of the parking. In my opinion, it was an ill-conceived idea. When it was voted down, we were not surprised. I was quietly pleased, but I certainly didn't advertise that to the client."

This almost two-year period in Asheville's history proved pivotal in leading to Asheville being touted today as unique, eclectic and quirky. Much of the

town's originality would have been lost if a mall had taken center stage. Plus, as Long pointed out, if the developer had backed out or declared bankruptcy on the project once the buildings had been demolished, Asheville could have been left with one giant mud hole.

GAINING MOMENTUM

*I remember when **I** first moved here* [in 1974], *I was at a dinner party one night
and I said, "More people need to know about Asheville—it's unbelievable." And
they said, "Oh no, we don't want anybody else to know about it."*
—*Lou Bissette, attorney and former mayor of Asheville*

With the referendum soundly defeated to build a mall downtown, the
question remained: How can Asheville transform into a place that's
vibrant and thriving again?

Today, Asheville is on just about every top ten list you can imagine. It's
noted for its beer, art, music, architecture and scenery, among other things.
But back in the early '80s, much of downtown was boarded up, drab and
desolate. Being named to any "best of" list seemed improbable.

That's why it surprised me then, and still catches my attention today, that
in 1982 Asheville was named the most livable small city in the country in a
book called *Places Rated Almanac*. Authors Rick Boyer and David Savagneau
spent years compiling U.S. Census data and other government statistics. They
ranked towns based on data drawn in nine categories: climate and terrain,
housing, healthcare and environment, crime, education, arts, transportation,
recreation and economics.

Boyer followed his own advice by loading up his family in Boston and
relocating to North Asheville. He was writing "Doc Adams" mystery novels
during the time he arrived in town—he had received an Edgar Award for his
first mystery novel, titled *Billingsgate Shoal*—and he was quickly hired as an

The author on the front porch of the Thomas Wolfe Memorial with famed writer Kurt Vonnegut and her dad, Ray Hardee. *Author's collection.*

instructor at the University of North Carolina–Asheville, where I took two of his classes: Magazine Writing and Mystery Writing. He later spent years teaching at Western Carolina University before his retirement.

He studied under Kurt Vonnegut when he was a student at the University of Iowa and subsequently invited Vonnegut to Asheville, where, at Boyer's invitation, I got to meet the famed writer one Sunday morning on the front porch of the Thomas Wolfe Memorial.

At the time of this writing, Boyer's health has declined to the point that makes interviews impossible, but his close friend Pat McAfee remembered that not everyone in Asheville was happy about *Places Rated Almanac* casting the town in such a favorable light. Not only did it appear in the 1982 volume, but in 1983, Asheville was also named the second-best retirement location in America in the *Places Rated Retirement Guide*. "According to Rick, he received death threats from people in this area for telling people about Asheville," said McAfee.

It seems that at least for some, having Asheville a well-kept secret, even if downtown was a ghost of its former self, was preferable to having it flooded with tourists and transplants. There seems, through every generation, an outward desire to see Asheville thrive and prosper while quietly wishing it could stay a secret.

FORWARD MOTION

Meanwhile, city leaders and business owners kept slowly pushing forward in their goal to revitalize the downtown area. Key projects in the '80s included the Wall Street Project, Pack Place Education, Arts & Science Center and the construction of two parking decks—one on Wall Street and the other on Rankin Street.

"I've got to give a lot of credit to Doug Bean, who was city manager while I was mayor," said attorney Lou Bissette, who served as Asheville's mayor from 1985 to 1989. "He was a real student of downtown redevelopment. We could talk at city council and have big ideas, but he was the guy who could go out and really get it done."

Bissette looks back to that time and names the Pack Plaza project as one he is most proud of, but it didn't come without a lot of pain. With buildings half demolished, the developer went bankrupt. "It looked like bombed-out buildings about half torn down," Bissette said. He had a visual reminder every single day as he passed the site while going to work. Getting the project moving again proved difficult.

"Everybody was saying, 'Look what you've done! You've torn all these buildings halfway down, and now you can't finish them.' We couldn't get a bank in the U.S. to finance it," he said. "We finally got the Bank of Scotland. They made the loan to restart the project. That, of course, was a big boost, but it was painful."

Bissette gave credit for downtown's renaissance to people like John Lantzius. "He was one of the originators, and he did it without any government incentive money or anything. He just did it on his own," said Bissette. Additionally, he praised the work of Roger McGuire, a former *Southern Living* executive who retired with his wife to Asheville in 1980. McGuire is most notable for spearheading the establishment of Pack Place, but he also worked tirelessly in many ways to help revive Asheville and lead it on the path to the success it enjoys today. Pack Place opened in 1992, and McGuire died two years later at age sixty-six.

Bissette also gave a nod to business owners who took some big risks investing in downtown: Bill and Shelagh Byrne, who opened Café on the Square in 1990, and John Cram, owner of the wildly successful New Morning Gallery in Biltmore Village, who pinpointed a deserted stretch of Biltmore Avenue to open additional businesses: Blue Spiral 1 art gallery and the transformation of the Fine Arts Theatre from a porn house to a theater showing first-rate indie films. He later opened Bellagio Art to Wear nearby.

Left: Lou Bissette Jr., attorney and former mayor of Asheville. Many positive projects for Asheville were developed during his years in office. *McGuire, Wood & Bissette, P.A.*

Below: This is how the Grove Arcade looked in Asheville's ghost town years. *Pat Whalen.*

"People say, 'How did you do it?' It was just a little bit at a time," said Bissette. "It was building and building until finally it got to the point that there was a reason for people to come downtown. You could find a place to park, good restaurants, art galleries, fine arts, and then from that it just kept getting more popular and more popular. It was a lot of people working and wanting the city to be better."

Bissette's advocacy of Asheville continued past his time in the mayor's seat. The Asheville Downtown Association (ADA) named him a 2013 recipient of the Downtown Heroes Award. The award recognized him for work on numerous boards, including the Asheville Area Chamber of Commerce, Blue Ridge Parkway Foundation, Asheville Merchants Corporation and the Buncombe County Economic Development Commission.

In addition, the award applauds him for being instrumental in the renovation of the Grove Arcade. Bissette said that returning the Grove Arcade to its intended purpose as a public marketplace would have never happened without the energy and determination of Aaron Zaretsky. "He had a vision for the Grove Arcade. He actually willed that thing to happen," said Bissette. "You think, how could he have gotten the money to do that, but he never gave up. He was persistent. He had some ideas about tax credits for

This is how the Grove Arcade looks today after a remarkable restoration. It features a lively mix of restaurants, shops and condos. *Photo by John Warner, courtesy of the Grove Arcade.*

investors that I'd never thought of. There's a tax credit on the air rights for that building so that nothing can ever be built above it."

"He had a great vision," he continued. "He was a developer. Once it was finished, he was not a great operator, and he made a lot of people mad, but I tell people all the time that if it hadn't been for Aaron Zaretsky that would not be here. The Grove Arcade is really a gem for downtown."

Bringing Life Back to Pack Square

Bill and Shelagh Byrne were living in San Francisco in the late 1980s when they decided that they wanted to be closer to family on the East Coast. They had a dual dream with another couple of going into partnership on a new restaurant. They thought of Burlington, Vermont, among other places, but the Byrnes fell in love with Asheville after the other couple recommended giving it a look.

Growth was occurring in downtown Asheville, but even in 1989, many buildings were still boarded up, sidewalks were empty and developers were desperate for anchor tenants. "We were first connected to another real estate broker here in town who circled all around. He dragged us up and down Wall Street and really wanted us there and also took us to Haywood Street, but he never brought us onto Pack Square. We didn't know there was 150,000 square feet of vacant space there," said Bill.

They eventually stumbled on Pack Square on their own and wound up striking a lease agreement with Ted Prosser, who at the time was property manager for Schneider Nine. "There's great irony about Asheville eventually becoming Beer City," said Shelagh. "When we were in San Francisco, Bill was a very good beer brewer. That was his hobby. When we came, our whole plan was to open a brewpub. One Biltmore Avenue was the perfect location. We were so excited. But we realized we just didn't have the funds."

Shelagh continued, "A lot of people said, 'That will never go in Asheville. How can you think about opening a brewpub?' But we looked at the financials, and we decided we couldn't afford it, so we went to Plan B, which was fine dining based on the Clement Street Bar & Grill in San Francisco. People still said, 'Ooh, that's still not going to go in Asheville,' but we persevered with that plan."

Bill remembered a day when he was lying on his back painting when a man entered the building. He introduced himself as David Adler, a man

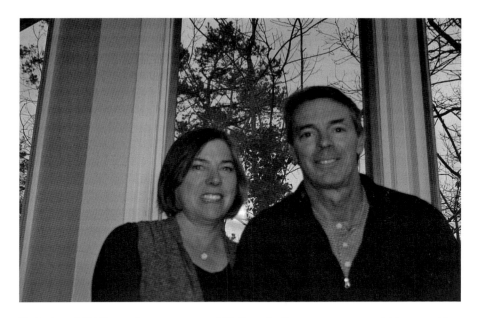

Shelagh and Bill Byrne, former owners of Café on the Square restaurant, which opened in May 1990 and helped rejuvenate an ailing downtown. *Shelagh Byrne.*

who had operated the GI outlet in that location for thirty years. "He looked around and said, 'What are you doing?'" remembered Bill. "I said, 'We're putting a restaurant in here.' He had this old man cackle of a laugh and said, 'You're crazy!' and walked out." Bill said that memory makes him smile every time he thinks about it.

They opened Café on the Square in May 1990, and indeed many people thought they were crazy for launching a fine dining restaurant in a town that basically shut down at the end of the workday. To provide a visual, Bill said that at the time they opened, if you went from the BB&T Building down to where Wicked Weed Brewing is located today, there were just a few businesses open: Café on the Square, Fain's department store (where Mast General is today), Fish Skins (where Doc Chey's is today) and the Hot Dog King. That was about it. Other buildings sat empty and boarded up.

Improvising became the name of the game as they worked to meet their soft opening. When it was taking too long to get the city to connect the water, they rented a jackhammer. "Ted and I were jackhammering a connection down the back alley and tapped into the city's water supply. The connection was there, but the two hadn't joined, so Ted and I were doing it in the middle of the night. We actually bathed in the fountain on Pack Square," said Bill.

"I was their lookout," Shelagh remembered with a laugh. "They were naked and jumped in the fountain to get all this mud off of them. Not a soul around."

Mr. Adler's comment that they were crazy rang frequently in their ears during the early days as they worked sixteen-hour days and put some cash advances on their credit cards to make payroll. "You can go downtown on the coldest, rainiest, miserable February night, and it will be more crowded than some of our busiest nights in May and June," said Bill.

A wonderful turning point came when Prosser called them in early 1991 with some incredible news. He had rented out the entire building above their space for the production company working on the movie *Last of the Mohicans*. Suddenly Daniel Day-Lewis and Madeline Stowe were in the restaurant all the time, and Café on the Square became the place to spot a movie star in Asheville. "We went from real insecurity and despair to this magic of being *the* place with a waiting list. It was exciting," said Shelagh.

While the movie connection gave them notoriety, they continued pulling long hours and working different shifts so one of them would always be home with their oldest son. Three years into the venture, Bill said that he was cleaning table C-2 when the realization hit him: "We're going to make it."

Their risk of opening a fine dining restaurant in a desolate downtown had paid off, and as other business owners began to move in, Café on the Square began to experience Asheville's renaissance firsthand, with an influx of regulars as well as a steady stream of tourists.

Ironically, just when the Byrnes had reached their sweet spot operating Café on the Square, an unsolicited offer came in to buy the business. It wasn't an easy decision. They had reached a comfort level with staff and the flow of business that would have allowed them to step away a bit and take vacations. Their second son was a baby, and with two children, they ultimately decided to sell and devote time to raising their family.

Tracy Adler took over the business in 1998, and as Shelagh said, "Magical things happened to her as well." Not only was her name Adler and she was taking over a business in the Adler building (no family connection), but she also found fame one day while bussing tables in the restaurant. A diner noticed her beautiful complexion and natural beauty. She approached Adler and introduced herself as Roxanne Quimby, founder of the Burt's Bees company. She offered Adler a chance to do some modeling for the company, and Adler soon appeared as one of the faces on the Burt's Bees Healthy Treatment line of products. A moment of Asheville serendipity at its best.

URBAN TRAIL

The 1990s gave birth to an unusual way to explore Asheville's legends and lore—a 1.7-mile trail around town that provides a glimpse at history through statues and markers. It's called the Urban Trail, and volunteer Grace Pless was a driving force in seeing it to fruition. She's modest in her accomplishment, but she worked tirelessly along with other volunteers under direction of then director of downtown development Leslie Anderson.

"It was strictly a volunteer committee," she said. "I was chairman for a long time. The miracle of the Trail is that people came to me to participate. I wasn't beating the bushes for funds. By 1993, we put in the first stations, and from then, every year until 2002 we would have some sort of celebration and reveal new stations. Our goal was to draw a spread-out downtown together and tell the story through art. I was really excited about that idea."

There are thirty Urban Trail sculptures scattered around downtown. Pless said that her committee never envisioned having tours associated with the Urban Trail. They thought, instead, that "you'd just serendipitously find them."

A sampling of the statues includes a giant flat iron, which stands adjacent to the Flat Iron Building on Battery Park; an abstract forged metal sculpture in front of Malaprop's bookstore that depicts three women shopping; an iron bench and bower of medicinal herbs to celebrate the legacy of the first female doctor in the United States, Elizabeth Blackwell, who was from Asheville; bronze cats

Grace Pless spearheaded a plan to bring Asheville's Urban Trail to reality. *Photo by Marla Milling.*

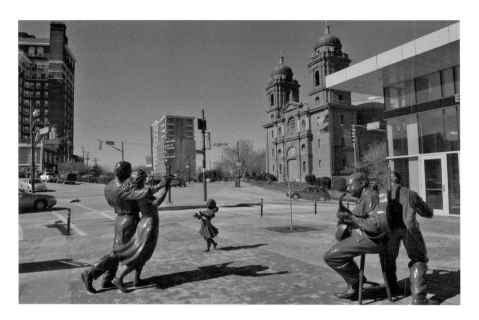

Statues in front of the U.S. Cellular Center depict men playing banjos and a couple dancing, along with a young child. The Battery Park Hotel, Indigo Hotel and Basilica of Saint Lawrence are visible in the background. *Photo by Marla Milling.*

on Wall Street crafted by sculptor Vadim Bora; and a bronze replica of the shoes of author Thomas Wolfe in front of the Thomas Wolfe Memorial. In all, there are thirty stops along the Urban Trail.

Pless has some fun family connections with the Crossroads stop on the trail in Pack Square. There are pigs and turkeys, and as she says, "The footprints of the Native Americans are my children's footprints, and my husband's boots were the drover's boots." Each station on the Urban Trail has its own fascinating history, and Pless is working on writing down tidbits about each one to put in the archives at Pack Library.

Pless grew up north of Greensboro near the Virginia line, daughter of an Episcopal minister. Her husband, Dr. Cecil Pless, is an Asheville native. She's been calling Asheville home since 1957. They have four daughters. "I truly love Asheville. I've been super happy here," she said. "I'm absolutely thrilled beyond measure to watch its growth. My husband and I love to travel, and back in the '70s and '80s, we could tell people we were from Asheville, and they'd say, 'Oh, is that near Raleigh?'" Now everywhere they go recognition of Asheville is immediate.

THE TOWN THAT JULIAN BUILT

Julian Price was a pioneer of downtown living. He was living on Battery Park in the upstairs of a building. He used to joke and say, "Everybody says I'm being so wonderful, but really this is my enlightened self-interest. I'm making this a great place for me to live, too."
—Pat Whalen, Public Interest Projects

Weird might well have been a word that jabbed at Joan Eckert's mind when a customer at her small lunch counter business in the basement of Asheville's YMCA offered a no-strings loan to grow her business. She and her husband, Joe, had moved their two kids from Philadelphia to Asheville in 1991, and her mother gave her $10,000 to buy the lunch counter at the Y.

After running the Laughing Seed for about six months, a regular customer quizzed Joan about whether she wanted to grow the business. When he offered a loan to open a restaurant, Joan saw many red flags. She couldn't believe that a stranger would just offer to lend money. When she and Joe talked with friends in Philly, they all echoed skepticism, saying, "This is crazy. Why would anybody want to loan you money to build a big restaurant? Who are these people?"

They postponed making a decision, but finally Julian Price and his business partner, Pat Whalen, convinced them that it was a good deal. "Julian said, 'If it doesn't work, you don't have to pay anything back,'" remembered Joan. "I don't know that we would have taken it otherwise, but it was still terrifying to borrow $300,000 from this guy we barely knew and who barely knew us. I

don't think he had our Social Security numbers until the day we signed. I don't think he did a background check. He was my customer, and he thought the food was good and he thought we were good people so he went for it."

They scoped out buildings throughout downtown, and they ultimately picked a spot on Wall Street. It was a time that, as Joan said, "literally we could have had almost any building we wanted."

After extensive renovations, the Laughing Seed Café opened for business in June 1993. The Eckerts are now divorced but remain business partners. It took a few years to get in the black, but they ultimately paid Julian back in full. "We did not turn a profit the first year. They had to loan us more money," said Joan. "By the second year, we were in the black. Julian was definitely a visionary. Looking back, I feel so blessed. It's almost unbelievable."

They expanded the business in 1996 (this time without Julian's help), when they opened Jack of the Wood bar in the same building. "It was the second brewery in Asheville," she said. "Green Man Brewing started there."

JULIAN'S STORY

Price, originally from Greensboro and grandson of Jefferson Standard Insurance executive Julian Price, returned to North Carolina after years of living in California. "Julian told me he moved out west because he didn't want to be in N.C., where his name is so well known. His grandfather Julian Price was the one who created all the financial wealth," said Meg MacLeod, Price's widow.

"In his forties, he decided he wanted to come back home. He did a road trip around North Carolina looking for a place compatible with him, and he thought he'd found it in New Bern, where he put money down on a condo. But then he continued his road trip and wound up in Asheville. He happened to walk down Walnut Street. With Beaucatcher Mountain in the distance and two beautiful buildings in need of repair on each side of him, he began crying. He wasn't sure why he was crying, but felt he had to move to Asheville instead. The rest is history."

He created an apartment for himself in the Flat Iron Building on Battery Park Avenue and engaged his lawyer, Pat Whalen, into forming Public Interest Projects with him. "He asked me to start a company to invest money in businesses and projects that would help revitalize downtown Asheville," said Whalen. "Julian basically said, 'Here's my checkbook. There's $15 million behind that. Let's get this done.' He never said no."

Right: Julian Price walking up Walnut Street in downtown Asheville. During a visit, Price was struck by the beauty of the mountains and saddened by the desolate appearance of downtown. He pumped $15 million of his own money into helping to bring Asheville back to life. *Meg MacLeod*.

Below: The old Asheville Hotel (at left) and the old J.C. Penney building (at right) before Julian Price restored them. Today, Malaprop's occupies the bottom floor on the left and Mobilia on the right. *Pat Whalen*.

It's easy when a town is thriving to come in with designs of cashing in on its fame. What Price did was something that took more courage. He came into a forgotten downtown, fell in love with the place and its potential and steadily and patiently worked to push new energy into it.

Described as a very private man, Price preferred staying behind the scenes as he encouraged small business owners to dream big. He knew that the key to a vital town included making the sidewalks interesting with a variety of retail possibilities, including bakeries, restaurants, bookstores, galleries and music venues, as well as giving people residential opportunities downtown. He also supported a vast number of nonprofits like Mountain MicroEnterprises (now known as Mountain BizWorks), Asheville GreenWorks, Coalition for Scenic Beauty and Scenic North Carolina. He produced *City Watch* magazine and created the Pedestrian Action League, among other endeavors.

Price went to work in the 1990s purchasing dilapidated buildings that no one else gave a second look to and financing the dreams of many small business owners like Joe and Joan Eckert of Laughing Seed Café; Hector Diaz, owner of Salsas; Emoke B'racz of Malaprop's; and the late Laurey Masterton of Laurey's Catering, to name a few. He also spearheaded restoration of the Orange Peel, which *Rolling Stone* magazine has touted as one of the top five music halls in the nation. It's played host to such musicians as the Smashing Pumpkins, Jack White, Cyndi Lauper, Modest Mouse and Imagine Dragons, to name a few.

He saw the potential even when naysayers challenged his plans with negativity and skepticism. When Price and Whalen envisioned renovating the Carolina Apartments on North French Broad Avenue, a property manager said, "Put barbed wire around it and forget it. No one will want to live there."

Originally built in 1918, the apartment house suffered a major fire in 1991, forcing tenants to vacate. Price saw the potential, despite the naysayers, and went to work rebuilding the charred south wing, as well as completely renovating the remaining structure.

"Twenty-seven units were pre-leased before we finished the project, so we saw there was tremendous interest in downtown. It wasn't like we were the visionaries. The people were the visionaries—it's just that nobody had given them a product that would allow them to live downtown," explained Whalen. "What we discovered was that downtown residents changed everything. When the lights started coming on and people started walking on the sidewalks, five o'clock didn't become the end of the world anymore. It was amazing how one or two people walking their dog or

carrying groceries to their apartment made others feel like they would walk around that street."

Another big project they tackled included restoration of the old Asheville Hotel, which had sat empty for about thirty-five years, hosting flocks of pigeons instead of people. They renovated the building, putting condos upstairs and convinced Emoke B'racz to take on a major expansion of her bookstore Malaprop's for the street-level space. At that point, she was renting a much smaller space nearby on Haywood Street.

"We worked with Emoke and her staff for about a year to get them up to an enthusiastic level about taking on three times the space," said Whalen. "I was very concerned that when the big booksellers came to town we'd lose Malaprop's, so we encouraged them to do this and came up with a creative lease. We started them out way below the typical lease and said, 'If you do okay, you can then pay marketplace rent. Malaprop's has obviously become one of the anchors of downtown. It's a local institution—national institution, really. Their success has outstripped anything I ever envisioned or they envisioned."

Julian Price Project

Julian's widow, Meg MacLeod, spends much of her time in Holland now, and I recently connected with her there via Skype. She's invested in keeping his memory alive and has teamed up with his daughter, Rachel Price, to launch the Julian Price Project. Karen Ramshaw serves as the project coordinator.

"Before he came to Asheville, he read a lot about city livability and found people who were doing good things for the environment and for poor people and other things and he began interviewing these people all over the country," MacLeod said. "He educated himself a lot about what helps the world to be a better place, and he was very interested in the beauty and the aesthetics. By the time he got to Asheville, he really wanted a hands-on approach to the money he gave away. He wanted to see the effect of it instead of just sending it to one organization or another. He knew for a town like Asheville the best thing you can do is get residential downtown. Once you get more residents and more people on the street, people feel safer and it increases business trade."

"He didn't care if some of the money got lost or if he made mistakes," she continued. "He was giving money right and left to help with the economy,

the beauty and things to make people feel good—nice sidewalks, empty trashcans and good ramps for wheelchairs."

This new project will complement the holdings of Price's archives at D.H. Ramsey Library at UNCA. The plan is to collect video oral histories from people who benefitted from Julian's support. Each one will be about an hour and a half long. They'll then compile all of them into a three-minute video and a twenty-minute video. "We are hoping that Public TV will be interested and pick it up and have it become a longer video," she said.

They've also hired a writer to prepare a series of six articles focusing on different aspects of his life. The topics include "Julian the Person"; "Habitat, Ecology and Sense of Place"; "Doing Good by Doing Good Business"; "Everybody Counts: Investing in the Community"; "Speaking Out: Education and Advocacy"; and "Ripples of Inspiration—Asheville and Beyond."

"His approach was so unique. He was a true visionary," said MacLeod. "Julian was really about making life good for everybody."

A LASTING LEGACY

In the end, life is quite short. What you leave behind is your legacy, and for an artist—that is his soul poured onto canvas, sculpted into clay and stone.
—Vadim Bora

Vadim Bora barely spoke a word of English when he moved from his native Russia to Asheville in 1993. He did, however, already have connections—he'd made friends with members of a delegation from Asheville that visited Vladikavkaz, Russia, as part of the Asheville Sister Cities program.

"Kitty Boniske [who has lived in Asheville since 1952] was very involved, and she's actually the one who originally met with the counterpart over there," said Constance Richards, Bora's widow.

Richards said that when the delegation visited Russia, after a night of wining and dining, the hosts asked the group if they'd like to see an artist studio. They were a bit baffled at where they'd go so late at night to meet an artist, but when they arrived at a studio and knocked on the door, it was Bora who answered. He welcomed them in, and budding friendships emerged.

Welcoming friends and guests into his studio in downtown Asheville proved stimulating to his process of creating stunning works of arts. He would laugh, share drinks and stories and also continue to work amid the jovial groups filling his space on Battery Park Avenue.

Even though I didn't get a chance to meet him before his untimely death in 2011, I feel Vadim Bora's spirit every time I see his magnificent sculptures—

Vadim Bora and Constance Richards pose beside the sculptures of Cornelia Vanderbilt and her dog, Cedric, that Bora crafted for Antler Hill Village at Biltmore Estate. *Constance Richards*.

cats on Wall Street as part of Asheville's Urban Trail, a ten-piece set of life-size children playing in the courtyard of Mission Reuter Children's Clinic and the statues of Cornelia Vanderbilt and her dog, Cedric, ready to greet visitors at Antler Hill Village at Biltmore Estate.

While these are some of the more visible public works that the internationally acclaimed artist left in Asheville, he also created a prolific collection of painted portraits, oil landscapes, smaller sculptures, silver engraved jewelry and even caricatures penned on the multitude of parking tickets he collected for forgetting to add change to the meter in front of his studio.

"He never claimed a favorite medium," said Richards. "He used whatever expressed the idea best."

KEEPING THE LOVE ALIVE

Raised in Europe, Richards has strong ancestral ties to Western North Carolina. Her parents, Ken and Irene Richards, met while working at an American School in London. Constance was born in Germany, but she had exposure to Western North Carolina with yearly visits to see her grandmother and other relatives. Her mother is a Dillingham from the Barnardsville community of north Buncombe County.

Richards and her parents arrived back in Asheville for her junior high years. They bought the former Asheville Art Museum in the Montford neighborhood, and Constance began attending a private school but soon discovered that classmates couldn't come to her house because their parents perceived the Montford area in a somewhat negative light.

Those days have definitely changed, with Montford becoming a hot spot hosting many bed-and-breakfast inns and popular restaurants such as Nine Mile and Chiesa and serving as a desired family neighborhood with the renovation of the once stately homes, many with wide, sweeping porches. Montford is in easy walking distance of downtown.

After graduation, Richards headed back overseas. She spent nearly seven years in Russia serving as Moscow bureau chief for *Life* magazine. She also worked as a freelance correspondent and researcher for *Time* and as a production assistant and interpreter for *ABC News* in Moscow.

During a trip back to Asheville to visit her parents in the mid-'90s, Irene told her daughter they had met a wonderful Russian artist in town and that it would be someone for her to speak Russian with. Constance countered that she came home for vacation, not to speak Russian. She had plenty of people to speak Russian with, but as fate would have it, she did meet Vadim Bora at a later point; the two developed a fun friendship that evolved into an inspiring partnership, love and marriage.

While she's been as prolific in her own career as a journalist, author, food reviewer and director of the Grand Bohemian Gallery in Biltmore Village, Richards is most passionate about curating her late husband's work and keeping his talents and contributions alive.

It's easy to recognize the love Vadim and Constance shared—one only has to read the body language and smiles in their pictures and watch the intensity with which Constance prepares exhibits of his work. Her eyes light up when she speaks of Vadim. "I feel like it's a continued collaboration," she said of her efforts to keep his work in the public eye. Her aim is to do one

show per year. She doesn't sell his work, so she looks for grants and other ways to fund the exhibits.

"I do feel Vadim's around, and I hope I'm doing the right thing. He had his own opinions and I have my opinions, and it often clashed, but I listened a lot. He also left a lot of written things and ideas in notebooks, but I can't read his Russian handwriting." She's considered getting a native Russian speaker to assist with the translation because she feels his thoughts will provide a good guide for her in the future.

Continued Connections

Bora always took time to encourage young artists and to build connections with others in the community. This is a common theme in this book. Yes, Asheville has that "live and let live" flair with its quirky, weird personality, but what makes it such a freeing place is that people are generous with their time, talents and hearts here. "His lasting legacy will be in the sculptures that he left—the public art—but I think the real legacy is in the people that he touched and the encouragement he gave to young artists," said Richards.

Vadim Bora working on a sculpture in his studio. *Constance Richards.*

"I try to stay in touch with those artists. I recently bought a piece from one of his protégés. We did a scholarship, first through the Fine Arts League. When that dissolved, Suzanne Hudson of the Chaddick Foundation and artist Sharon Trammel and I got together. We all three said, 'You know, we have the Visual Arts Scholarship [at Asheville-Buncombe Technical Community College]; let's rename it for Vadim.' I'm very excited about it."

CREATIVE SPIRITS

What a lot of people don't know about Asheville, and you have to have your belly a bit to the ground to understand, but Asheville is home to some world-class graffiti writers. Really serious, super well-known graffiti people, and none of those graffiti writers go out and tag stuff. The taggers are the young kids who are trying to make a name for themselves.
—Ian Wilkinson, muralist

During a rainbow gathering in Colorado, Kitty Love was tattooing a guy's arm when he recommended Asheville as a great place to settle. So Love and her traveling buddies packed up their gear and hit the highway. "I'm sure we were a sight because we arrived in a school bus that was painted up like outer space," said Love. "It had a big astronaut on one side with a skull face and a giant shooting meteor on the other side. That was '94, and we basically parked and went from there. It turned out to be a false start, but I came back in '96 with my baby, Tristan."

She rented space from John Lantzius on Lexington Avenue and opened up a tattoo shop. She then met her soon-to-be-husband, Michael Mooney, and they started Sky People Gallery and Design Studio and also created the Lexington Avenue Arts and Fun Festival (LAAFF), which kicked off on three blocks of North Lexington Avenue. The festival ran yearly beginning in 2001 but was canceled in 2013. In 2014, it returned as a collaboration between the Asheville Area Arts Council, LEAF and Asheville Grown Business Alliance.

Kitty Love working her magic as a tattoo artist. *Kitty Love.*

"That was really the beginning of all of our grass-roots, fun, circusy, community-building endeavors, and the stories all spring out of that. The LAAFF festival provided that vessel," Love said. "In the first year, we created big people games, which in retrospect were not the most politically correct. We had Bowling for Karma with bowling pins painted up like Hindu deities, and you could bowl away your past life sins. We had Viking Croquet. The wickets were rebar and the mallets were sledgehammers and the balls were bowling balls, and you had to wear the helmet. And we had baby head putt-putt. That was the first year of the festival in 2001.

"We were still renovating when the Twin Towers went down," she continued. "We were still building our space out, so the business failed. It couldn't possibly have opened at a worse time. We were totally undereducated and undercapitalized and adventurous and passionate and silly. The business closed in 2005, but we got an awesome street festival out of it, and the murals that all the beer sales helped pay for are still up and look great."

Arts 2 People emerged out of LAAFF, and Love served as executive director for ten years before moving into her current role as executive director of the Asheville Arts Council in 2011. "In the third year, LAAFF

started making money, and we wanted to do something really meaningful with those funds," said Love. "We did educational programs. We did the Prichard Park Cultural Arts Program—that's where the Hoops Jam got its start. We also did a program with Our Voice working with survivors of sexual assault to do art projects leading up to their annual art show. We did all kinds of wonderful things. We had a dance company. We did the mural project. We had an artist resource center. Arts 2 People as an organization gave rise to a lot of really wonderful projects."

MURALS AND GRAFFITI

The beautiful murals under the I-240 overpass on Lexington Avenue provide a constant reminder of the positive work created through Arts 2 People. As Love said, beer sales at LAAFF helped fund the mural project. Molly Must was the driving force to get state approval to paint under the bridge. According to muralist Ian Wilkinson, Must breathed a lot of life into the project when she served as director.

Wilkinson got involved when pigeon drippings threatened to ruin the painting. Some builders gave opinions on how to fix the problem, but all came with some big price tags. "I have building experience, which gives me a serious advantage in the mural world over others who just paint," said Wilkinson. "We built a concrete curb on the top of the bridge to divert water off the other way, and that's how I got in, just knowing how to take what was becoming a $5,000 problem and turning it into a $20 problem."

He now serves as director of the Asheville Mural Project, and he also works independently as an artist and muralist. He arrived in Asheville five years ago after moving his family here from Santa Fe. While the New Mexico town has a proliferation of studios and art, he said it isn't a mural town at all, and he feels most in his element when he's creating murals. So, they decided it was time to move, and they randomly picked Asheville. Ian says it may literally have come down to the toss of a coin as to where they'd wind up, but it proved to be the perfect choice. "It's been amazing for my career," he said. "It's exploded since I've been here."

He recently teamed up with Alex Irvine to create the stunning *Daydreamer* mural on the side of the Aloft Hotel. Out of 150 applicants, their proposal won the approval of Asheville city officials, who hired them to complete

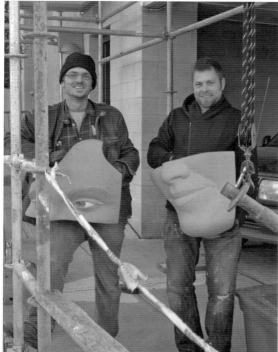

Above: The Asheville Mural Project is responsible for the incredible art on the Lexington Avenue bridge underpass. *Photo by Zen Sutherland*.

Left: Alex Irvine and Ian Wilkinson holding pieces of the face for the *Daydreamer* sculpture they created on the side of the Aloft Hotel. *Photo by Zen Sutherland*.

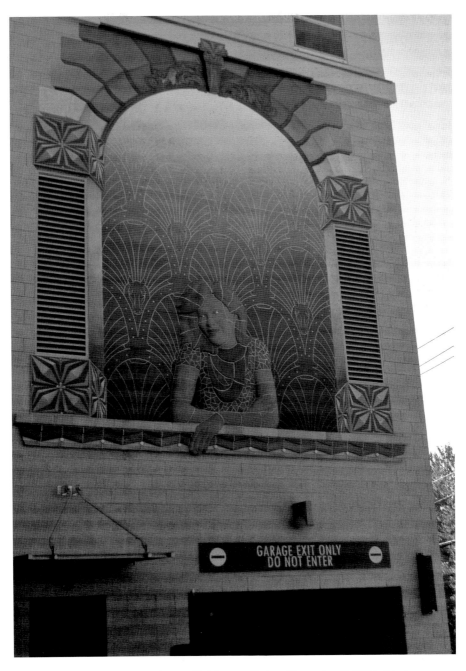

The stunning *Daydreamer* mural was officially unveiled on November 8, 2014. It's the creation of artists Ian Wilkinson and Alex Irvine. *Photo by Marla Milling.*

the project. They took impressive, costly steps to ensure the safe installation of the ceramic tile sculpture and watched any hope of a real living wage dissolve in the process.

Adding up the numbers made Wilkinson work even harder to support his growing family. His third child is due in the summer of 2015.

Colorful graffiti in the River Arts District. *Photo by Zen Sutherland.*

Graffiti at the old Dave Steel location in the River Arts District by M.O.M.S. The name was taken from a pen—"Marks on Most Surfaces." *Photo by Zen Sutherland.*

"Sometimes I would put in sixty hours a week on the project, but I also made seven other murals during the process of making that."

He completed a mural for the newly transformed lobby at Asheville's YMCA, and the City of Asheville also purchased a mural he completed three years ago for the Burton Street Community Center in West Asheville. "I'm the only artist who has gotten two pieces in the city's permanent collection in one year. 2014 was very good for me," said Wilkinson.

Asheville photographer Zen Sutherland documented the entire process of the mural creation under the Lexington Avenue Bridge, as well as creation of the *Daydreamer* mural as Wilkinson and Irvine worked to complete it. Sutherland also showcases area graffiti through his pictures. As an abstract photographer, he says he is most attracted to patterns, colors and shapes.

"That's sort of what attracted me to the whole graffiti thing. I'm also fascinated by the constant turnover. It's changing all the time. There are even people who tag a certain spot who will tag over their own work to put up a new piece," he said. "I began taking more and more pictures and putting them up on social media. I began meeting them online. There are different crews. For instance, M.O.M.S. is a crew. It comes from one of the pens they used that was a Marks-a-Lot, but it said, 'Marks on Most Surfaces.'"

1-2-3 GRAFFITI FREE

Coming up with a positive solution to unwanted tagging is high on Wilkinson's mind these days. He said that the City of Asheville tries to address the problem through a website called 123graffitifree.com, which flags tagged buildings and gives approved contractors the opportunity to buff them for pay.

"I joined the buff squad," said Wilkinson. "I buffed one building, the city inspected it and gave me a check. The day after I buffed it, someone graffitied it. I can't get out there fast enough. I get that the people don't want to look at graffiti, but the plan for graffiti removal is super one-sided. It's the 'torches and pitchforks' approach to getting rid of a monster. It doesn't work. Frankenstein is going to be back. Just paying someone to go and buff over stuff is just shaking the Etch A Sketch."

Wilkinson's plan is to identify good sites and work with the city and the building's owner to buff the tagging and replace it with a beautiful mural.

"The amount they are paying to buff a spot is more than enough to paint the spot," said Wilkinson. "If the owners could match it, we could do really cool things. When you see cool things by respected people, no one is going to come and write their names on top of that."

AN ECLECTIC MIX OF PERSONALITIES

*One of my favorite things about Sister Bad Habit is running around
and making people smile.*
—Jim Lauzon, owner of LaZoom Tours

Just as the eclectic mix of architecture, businesses and history lends to the creative flair in downtown Asheville, there's also a surprising mix of personalities who draw attention with their talents, knowledge and zaniness. The Zen saying, "You never step in the same stream twice" holds true for Asheville as well—you'll never step into the exact same town twice. It's as if Asheville is a living entity that's changing and evolving each day with unexpected sights and personalities roaming the streets. If you're lucky, you might just stumble on some of the people I've profiled in this chapter.

SISTER BAD HABIT

If it's possible for someone's eyes to dance, Jim Lauzon's do. His expressive face, exuberant smile and quick laugh keep the energy high. It's easy to see how he's met his calling by dressing in drag to earn a living.

Jim, who owns the LaZoom Comedy Tour Bus with his wife, Jen, dons a nun's habit and black dress to transform into Sister Bad Habit, one of Asheville's most recognized and celebrated personalities.

There's even a Sister Bad Habit Ale, thanks to the brewers at Asheville Brewing Company.

On the day I met with him at World Coffee Café on Battery Park Avenue, he'd left the nun's attire at home but continued to generate smiles with his quick humor and surprising spiral hoop earrings in a vivid shade of blue. Or maybe it was turquoise. I didn't have time to examine the color too closely, as I was too busy laughing at his fast-paced dialogue of hilarious anecdotes.

He learned a lot of his antics and skills, like fire eating and riding an extra-tall bicycle, by hanging out with New Orleans Mardi Gras folks and circusy types. He followed their path after tossing in the towel on his Amtrak job working as a train engineer. He made good money, but what's good for the bank account isn't always what's best for the soul, so he left to pursue his passion of making people smile and laugh.

After Katrina hit New Orleans, Jim and Jen decided to move with their six-month-old daughter, Liv, and first thought they'd head to Wilmington, but then people started telling them, "No, go to Asheville." They came, fell in love with the place and moved up within two months of their initial visit. They first set up as street performers, and then they moved into other positions—Jen as a special education teacher at Ira B. Jones Elementary and Jim as a waiter at the now-defunct Thibodeaux Jones restaurant.

An idea for a comedy tour bus kept swirling in his mind, and finally he told Jen that it was now or never. They quit their jobs, put a lien on their home, bought a bus at an auction in Pennsylvania for $6,000 and created a business. They hired someone to drive the bus to Asheville. "When we woke up, we were just staring at this beast in our yard," said Jim. "We were like, 'Oh no, what did we do?' We were really tripping."

Pushing thoughts of regret out of the way, they regrouped and set their plan into action. "We made it up as fast as we could. The biggest line we used to tell people because we didn't have enough material is, 'Just look around. Just look around. Isn't this town pretty?'"

When they wondered what type of skit they would do around the basilica, Lauzon says he pulled out a nun's habit he had, bought a black dress at a thrift shop and jumped on the bus. "I said, 'I'll be Sister Bad Habit.' I just made up the name," he said with a laugh. "I went to Catholic school, and Sister Pauline is who I model my character after. She was old, and she would fart sometimes just walking around the desks. We'd be like, 'Oh no, here she comes.' She was real curmudgeonly and self-righteous, and I liked that."

During tours, Sister Bad Habit is often seen pedaling beside the bus on the tall, cherry-red bicycle, but Lauzon is planning something new for 2015. "I

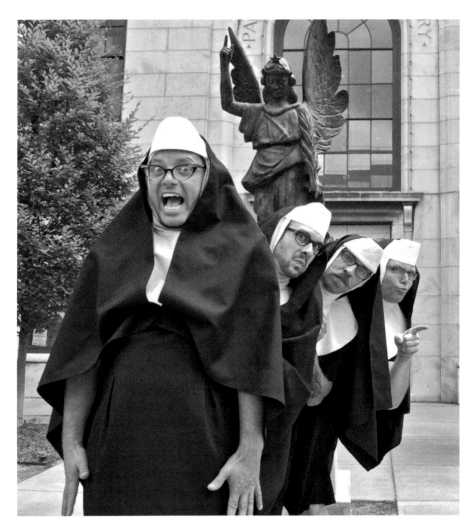

Sister Bad Habit and the other nuns from LaZoom Comedy Tours. *LaZoom.*

have a couple of power wheelchairs. I'll take off the base and create my own platform. I'll be strapped in safely and then steer with my toes. The dress form will go over that. I'll have to practice. It will be a new performance art, going down the street with a ruler."

There are other "nuns," like Sister Sour Kraut and Sister Harry Mary, who work during Lauzon's time off, and during those moments, he might be on the bus listening to comments. It's the best way to hear unfiltered, honest commentary when customers don't know they are seated near the owner. He

says his favorite was a conversation he overheard after one of the other nuns exited the bus during the tour. "That's not the real nun," one passenger said. "The real nun, Sister Bad Habit, dresses like that all the time. That's how she lives." "I laughed so hard," said Jim.

One of Sister Bad Habit's biggest secrets is that "she" uses maxi pads. Riding a bike can be hot and sweaty, so the white band of the nun's habit that fits across Lauzon's forehead can get sticky and gross. The fix is to apply a maxi pad to the habit, and this keeps his forehead comfortable. "My wife hates it. If I've been in her car, there might be a pad [adhesive strip]. She's like, 'People will think I change them at the red light.' Now I have my own pads and she has hers," Lauzon said.

Sometimes, to ratchet up the hilarity, he will stick one under the dress and pull it out to shock riders or passersby. One day Sister Bad Habit was sipping a beer outside Thirsty Monk when another couple struck up a conversation. Lauzon said, "It sure is hot," as he reached under his dress, pulled out the maxi pad and began wiping sweat off his face. Then he slapped it back under his skirt.

"It's amazing what this character can bring out. She has the innocence of being a nun, yet when she opens her mouth, you're like, 'Oh my gosh.' There's always fire coming out," he said.

ABBY THE SPOON LADY

I keep glancing at the hands of Abby "the Spoon Lady" Roach during breakfast one morning at Early Girl on Wall Street. Tattooed vines and leaves crisscross the top of her hands and up some fingers. And it's those slender fingers that she uses to make her living—sliding and clacking spoons together with such natural, instinctive rhythm. It's magical to watch Abby play the spoons when she's busking on Asheville's streets.

Originally from Wichita, Kansas, Roach fed her wanderlust by hopping the rails to travel to various places across the country. Busking became a way to get from point A to point B. She taught herself to play the spoons but said that there aren't any real resources for advanced spoon playing. "You just have to sit there and figure it out," said Roach. "Rhythm came real easy to me, and the spoons are very portable. The joke I tell people is that my parents didn't get me a drum set."

Landing in Asheville was purely accidental, although an optimist could say it was a serendipitous date with destiny. "I literally took the wrong train," she

The tattooed hands of Abby the Spoon Lady, one of Asheville's most popular buskers. *Photo by Marla Milling.*

said. Asheville proved to be a welcoming place and a town she's continued to spend time in for ten years now. While she's traveled back and forth to places like Nashville and New Orleans to continue busking in those cities, she now has a goal of spending the majority of her time in Asheville.

Most often, Abby plays spoons near the flat iron sculpture at the corner of Battery Park and Wall Street, as well as at various spots along Haywood Street, often teaming up with Chris Rodrigues. They are part of the Asheville Buskers Collective, which formed in 2014.

Abby knows how to draw a crowd on the streets of Asheville, but she's also gathered attention from the producers of *America's Got Talent*, who have expressed interest in having her on the show. She loves the fact that she's preserving the tradition of spoon playing while offering up something that's a bit unexpected.

"People in Asheville are really open to more creative things being pushed in their faces, so they're a little more open to me when they come around the corner," said Roach. "I represent a sort of weird storybook character. They might come off the Blue Ridge Parkway into downtown, and there's this barefoot, toothless woman playing the spoons. I mean it's stereotypical as all hell. Let's be honest. I'm okay with it. I'm totally on it."

A group of Asheville buskers, including Abby the Spoon Lady, plays in front of the flat iron sculpture at the corner of Battery Park and Wall Street. *Photo by Marla Milling.*

When she's not playing spoons, Abby stays busy with a variety of enterprises, from working on a CD to selling copies of a brochure that outlines spoon playing techniques to appearing on radio shows. In her downtime, she says she's a bit of a computer nerd and loves hanging out at the warehouse she lives in with a bunch of other artists. It's situated on more than seven acres, and they enjoy a good community life with wood stoves, chickens and peace and quiet.

JEFF PITTMAN

Depending on the time of day or season, the buildings in downtown Asheville have different personas. Sometimes sunlight spotlights the terracotta tile on some buildings; other times details are framed by stormy skies or fluffy clouds. Artist Jeff Pittman pays attention to the nuances when he

spends time downtown. While he isn't a plein air painter, he does know how to capture a moment in time as he re-creates Asheville's skyline on canvas.

"I take a lot of pictures," said Pittman in his studio on Depot Street in the River Arts District, located adjacent to the Junction restaurant. "It's easier for me to work that way. If you go downtown, it's so crazy and busy I can't imagine setting up an easel in the middle of a crowd." He doesn't mind, however, having visitors to the studio he shares with five other artists stop in to watch him work and talk about the process. He started out painting in his garage as a hobby. Now he does most of his work in the studio.

Pittman grew up in the eastern part of North Carolina and had exposure to a very talented artist: his dad, Bob Pittman, whose paintings include coastal art, lighthouses, landscapes, buildings and other subjects. The funny thing is that Jeff never tried his hand at painting until after he and his wife, Cassie, moved to Asheville in 1997. He had gone to NC State University for engineering and then moved to Boston for music school. He came to the Asheville area to work for a recording studio.

"I got my first set of paints before we had kids, and I had free time late at night," said Pittman. "I started painting scenes of Asheville and found that people were buying them. That really fueled the fire. At my first Bele Chere, I was surprised how many scenes of Asheville people were interested in. I

Artist Jeff Pittman paints in his River Arts District studio. *Jeff Pittman.*

had just done it on a whim because I liked it and found other people liked it, too, but I don't think I could have done this in any other town. I think it's the culture of people wanting to buy a part of Asheville or to support artists living in Asheville."

His hobby quickly turned into a full-time career. He now devotes 90 percent of his work time to painting and running the studio and 10 percent of his time to the recording studio, where he still works a few hours a week. This gives him much-needed freedom and a flexible schedule that's necessary with three kids ages twelve, nine and six and a wife who has unpredictable hours working in real estate.

One of his best-selling scenes shows a view of College Street that highlights Tupelo Honey Restaurant. He's also painted the Orange Peel, Salsa's, the Wedge Brewery and Woolworth Walk, where he has had gallery space since about 2003. Other work features various skyline angles of Asheville, area churches, other businesses, neighboring towns and stunning panoramic mountain views.

A view of downtown Asheville as created by artist Jeff Pittman. *Jeff Pittman.*

"The thing about Asheville is they are always adding or revamping a hidden gem or bringing in a new restaurant or brewery. I think the more Asheville evolves, the more I'll have to paint," said Pittman. "I paint when I feel like it and then go for a hike or walk around downtown with a camera. Sometimes when it seems like I'm goofing off, I'm really looking for the next subject."

TIZIANA SEVERSE

Tiziana Severse personifies the creative spirit that flows through many Asheville residents. By day she styles hair at Aubergine Salon on Broadway, but at night she's working on her art, which is music. This is what many people do in Asheville—work to pay the bills and then invest time doing something creative to feed their souls.

She sings with the band Yours Truly, currently recording their first album. She previously sang with a band called Albatross Party, but that band is no more. Meg Mulhearn, who plays the electric violin with U.S. Christmas, a psychedelic rock band out of Marion, North Carolina, will add her talents to the new album as the producer and guest member.

"Her art is very unusual and avant-garde," said Severse. "She uses the violin to create a series of loops. She thumps it to make a rhythm. She blows on it to make a hollow sound. She'll pluck the strings for a bass effect, and she stacks all these sounds on top of each other to make a song out of it. Nobody is doing what she's

Tiziana Severse. *Photo by Marla Milling.*

doing with the instrument. She uses all parts of the instrument in every possible way. She's incredible."

Severse was living in Hawaii when her life transitioned to North Carolina. Some folks she knew from the island of Maui moved to Hendersonville. She came for a visit and never left, but she found that Asheville was more progressive than Hendersonville and a better fit for her. She's also discovered that different sections of Asheville have different defining characteristics. "I live in West Asheville and work in downtown," she said. "Places like Swannanoa or Candler aren't going to have the same feel as West Asheville or downtown. Everywhere I go in my community, everyone is doing some sort of art form. Everybody is doing something that gratifies and edifies them as a human being."

When she's not singing or styling hair, Tiziana spends time thinking about the mind/body connection and talk therapy—seeds perhaps of a future career. She's currently enrolled in psychology classes at AB-Tech.

"I think our connection to the esoteric forms of healing is what makes Asheville weird," she said. "We have a large amount of people focused on unusual or psycho-spiritual forms of healing. There are salt caves in Asheville, isolation and deprivation tanks, past life regression therapy, hypnotherapy, rolfing—I think those things exist in many places, but for a town as small as this is, we have a highly concentrated number of practitioners as well as participants. I think this is one of the reasons Asheville keeps getting voted 'Happiest Place on Earth.' It's because people here are spiritually connected and exploring whatever bizarre and unconventional forms of healing are available to us."

THE MAN IN WHITE

In the past decade, Ralph Longshore has completely reinvented his life. He knows the pain and struggle that such a transformation can bring, yet his voice exudes joy when he talks about how far he's come in bringing his dream of being a successful street performer into reality.

He first made a living for years as a carpenter. He worked for other people and eventually built houses with his own crew. But the recession of 2008 changed everything. "I pretty much lost work, lost my crew, and my tools began dwindling when I sold them to pay bills," he said.

His mother and stepfather had relocated to Asheville from Spartanburg, South Carolina, several years earlier and had been urging him to build a

new life in Asheville. He finally made the move after hitting rock bottom professionally and financially. When he moved to Asheville in late 2008 all he had to his name was his Mustang and a backpack filled with clothes. The hunt for a job didn't prove easy. He got some temporary work in construction, but after one particularly grueling day that only netted him forty bucks and caused him to sleep eighteen hours out of exhaustion, he decided that there had to be a better way to live.

"My whole world was changing. I didn't know what to think or what to do," explained Longshore. "When my stepfather moved to Asheville, he got into eating healthier and doing a lot of self work—self healing, meditation and listening to Eckhart Tolle tapes. He was preaching that stuff to me and tried to help me understand less is best and good to start over. I felt like God had a plan for me, but I didn't know what it was and really felt lost."

He noticed all the street musicians while walking around Asheville and decided to give it a try. He had a guitar and a love of music, so he teamed up with another guitar player and the two of them entertained passersby for three hours. "We made twenty bucks that day and split it," Longshore said.

He noticed the Silver Drummer Girl, a living statue that comes to life when people toss coins or dollars in her bucket. Once a donation is made, she taps out a beat on her drum and then freezes back into her statue pose. "I heard that drum keep going off, and every time it went off, I knew she got some change or a dollar," he said. "That's when a light bulb came on. I realized she had made about ten dollars in ten minutes."

He quickly brainstormed a way to build a living statue character of his own. He had his black guitar and thought that white would be a good color because he could find white clothing without having to spray-paint them. When he told his mother the plan, she liked the black-and-white scheme, saying that it reminded her of the yin/yang symbol and that it creates balance.

His first attempt of painting his face, head and hands wasn't too successful. He bought paint at an art store, but what he didn't realize was that he was buying paint for canvas instead of paint for skin. He couldn't move his face without the paint cracking. But that first venture gave him a preview that he could earn some bucks. He was out about three hours and made about eighty dollars. He invested his earnings into white shirts, pants and other things to bring his character together.

One day, he was sitting in a park with his mother and watched some birds fly down and land on a monument. That became the next addition to his persona. His mother found some black birds at a dollar store, and he added one to his shoulder and one to his guitar.

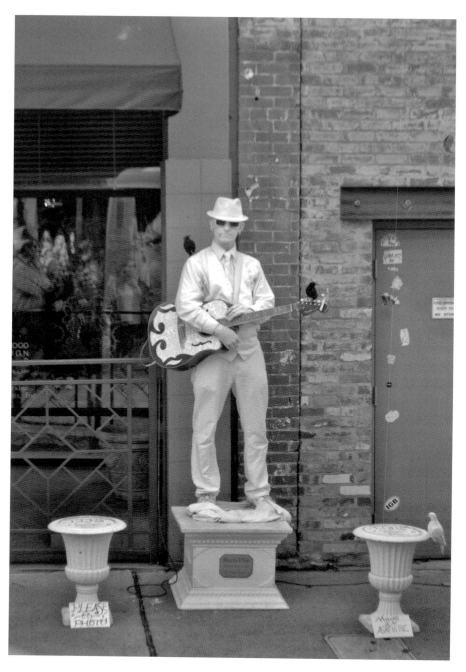

Ralph Longshore (aka "the Man in White") poses as a living statue on the streets of Asheville. *Photo by Marla Milling.*

As winter of 2009 set in, the streets emptied of tourists, and Longshore found himself struggling again. He made his way to Atlanta, where he worked some as "the Man in White," but to pay bills he wound up accepting a job in Savannah to help install windows on a military base. When the weather warmed up, he would come back to Asheville to perform as the Man in White on the weekends and then return to Savannah for four ten-hour days of work until that temporary job ended.

He met his girlfriend, Christa, and she took him to Michigan to meet her dad. When he heard of Longshore's street performance art, he gave him a white tuxedo he had tucked away in a closet. The vest and tie gave his character a whole different level of professionalism.

The couple now travels the country as Longshore perfects his character. They love Asheville and consider it home, but in the winters they head to Florida, Charleston and New Orleans. They also spent some time recently in California. In the summers, they often go to Michigan, and they have expanded contacts with art fairs and festivals where Longshore can work.

"I always put in 110 percent with my act," said Longshore, "but in some places it's still hard. We're growing, and I have to remember not to take things personally. Some days I make $20. Other days I make $120. Busking is about being at the right place at the right time. What's cool is that when I show back up in Asheville, the other buskers welcome me back and tell me what's been going on. I'm very blessed that we have that relationship. They respect me, and we have a good connection."

He specifically mentions Alex the Juggling Guy, Mark the Violin Guy and Abby the Spoon Lady as being members of the buskers community who are especially welcoming and supportive. He also has great admiration for Jessie, the Silver Drummer Girl. He calls her his "inspiration."

"When I first came to Asheville, there was just an energy coming into the city," Longshore said. "The drum circle was the best thing in the world. I looked forward to showing up on Friday nights and being part of that energy where everyone is happy. They say Asheville is like the new San Francisco, the good times in San Francisco. It's becoming to be that vibe with a lot of good people and a lot of great talent. People love the arts here, whether it's the street performers or an art gallery."

MOVIE MAGIC, LEGENDS AND ODD FACTS

I loved it. It's kind of like a little kind of hippie town. Kinda feels like people that used to follow the Grateful Dead have moved there to die.
—Actress Kristen Wiig describing her summer of 2014 in Asheville on the David Letterman show

Long before Asheville started showing up on lists of popular places to visit, moviemakers had already discovered the area as a stunning spot to serve as a backdrop to a multitude of films. And of course, since Asheville is routinely mentioned in all those top ten lists, there's also a recent one associated with the film industry. *MovieMaker* magazine named Asheville as the top town in its "Best Places to Live and Work as a Moviemaker in 2014."

One of the most recent movies shot in Asheville created a lot of excitement in downtown, with stars Zach Galifianakis, Kristen Wiig and Owen Wilson spotted frequently at area restaurants, farmers' markets, businesses and concerts. They were in town during the summer of 2014 shooting the movie *Masterminds*, set for release on August 14, 2015.

The Hunger Games trilogy also brought Jennifer Lawrence and other members of the cast to town. Movies shoots took place around the region.

Tom Muir, historic site manager at the Thomas Wolfe Memorial, is looking forward to the release of the movie *Genius*, due to hit theaters in late 2015. Actor Jude Law will portray Thomas Wolfe on the big screen. While it wasn't filmed in Asheville, Law did pay a visit in the summer of 2014 as he researched his character. He toured the Wolfe Memorial and spent some time in town.

POPULAR VENUE

While there are many different locations in Asheville and the surrounding mountains that have gained attention on the big screen, the Biltmore Estate has been the site of countless movies. Grace Kelly was here to shoot her last movie as a bachelorette, starring in the 1956 movie *The Swan*.

Some of the others that filmed at Biltmore include *Being There* (1979), starring Peter Sellers; *The Private Eyes* (1980), a comedy featuring the duo of Tim Conway and Don Knotts; *Mr. Destiny* (1990), starring Jim Belushi and Michael Caine; *The Last of the Mohicans* (1992), with Daniel Day-Lewis and Madeleine Stowe; *Richie Rich* (1994), with Macaulay Culkin; *Forrest Gump* (1994), starring Tom Hanks; *My Fellow Americans* (1996), featuring Jack Lemmon, James Garner and Dan Akroyd; *Patch Adams* (1998), with Robin Williams; *Hannibal* (2000), starring Anthony Hopkins; and *The Odd Life of Timothy Green* (2012), with Jennifer Garner and Joel Edgerton.

LINGERING MEMORIES

There are also stories of other celebrities that linger in Asheville. Actor Charlton Heston and his wife, Lydia, lived in Asheville for a year in 1947 and served as directors of the Asheville Community Theatre. The Hestons returned to Asheville in 1992 to take part in an ACT fundraiser. They performed the two-actor play *Love Letters*.

The Beaufort House Inn bed-and-breakfast in Asheville served as the Hestons' home during the year they worked in Asheville. The inn is just north of downtown at 61 North Liberty Street—close enough for the Hestons to walk to the theater.

John F. Kennedy Jr., made an appearance downtown in the '90s when he came to Asheville for a wedding. Shelagh Byrne, former co-owner of Café on the Square Restaurant, can only laugh when she thinks about the near miss of entertaining him in the restaurant. She said that she had been up front all day but had gone to the back as they were closing down to prepare for the transition to dinner. During that time, Kennedy entered Café on the Square. An employee from Canada was at the door and told him that they were closed and referred other restaurants. She didn't recognize Kennedy, but just as other staff keyed in to who was standing there, it was too late. He left, and they had a near miss with having him dine in the restaurant.

There are a few other star-related Asheville connections: actress Andie MacDowell made her home in the Biltmore Forest area for years, singer Gladys Knight has a home in Fairview and comedian Steve Martin lives in nearby Brevard. He began collaborating with the Grammy-winning Steep Canyon Rangers in 2009, playing banjo with them. He also teamed up with Edie Brickell on an album called *Love Has Come for You*, which includes the song "When You Get to Asheville."

WEIRD TALES

Tales of Walt Disney living in Asheville prove to be one of the town's biggest urban legends and have continually been debunked. Throughout the years, people have claimed that he worked as a draftsman for an engineering firm in the Jackson Building. As the often-told story goes, he was fired for doodling on the plats. It's a story that seems to go in cycles, with the newspaper writing periodic stories about this Asheville untruth.

Joshua Warren put up an exhibit in his Asheville Mystery Museum after thoroughly investigating the Disney rumor. His findings debunk the myth that Disney worked or lived in Asheville.

There's also a weird tale about a carved alien in the Asheville Mystery Museum. Darren Hussy of Maryland carved the statue and presented it as a gift to Rush Limbaugh. It was a joke of sorts because he had seen Rush Limbaugh depicted as rubbing elbows with aliens in an issue of the *National Enquirer*. He dropped it off at Rush's station, and Rush and his colleagues named it "Carville the Alien" because they said it looks just like James Carville. It later found a home with Art Bell and his family in Pahrump, Nevada. They were so scared of the statue that they wanted to get rid of it. Warren said, "The previous owner said his wife and daughter would often see the statue running around their house in the middle of the night."

After Warren acquired the statue and brought it to Asheville, he's had just one brief experience with it moving:

I used to have the Asheville Mystery Museum in another location—the old jail building behind Pack's Tavern. I was at the museum, alone with Carville 'til around 11:00 p.m. setting him up in his new display. I locked up and left for the night. The next morning, I unlocked the door, glanced in and was instantly surprised. Carville's entire four-foot-tall, one-hundred-

Carville the Alien at the Asheville Mystery Museum. Owner Joshua Warren said that this statue scared a former owner when he and his family "would see the statue running around the house." *Photo by Marla Milling.*

pound body had somehow shifted a good twenty-five degrees to the right. Nothing else was disturbed. I thought someone may be messing with me, so I checked the security footage of the entrance and the security logs. No one went in or out of this building, and I can't explain how he moved in the middle of the night. Afterward, I put a camera on Carville twenty-four hours a day but never captured a motion. This is a great mystery and my only personal experience with him moving.

Ghost stories are abundant in Asheville, with tales of many haunted buildings—Warren and his staff tell many during his Asheville Ghost Tours downtown, but there are plenty of others.

"There's talk of paranormal stuff going on at our Biltmore Village gallery. Customers have told staff about things that happened when it was the Melting Pot restaurant," said April Nance, PR director for the Folk Art Center/Southern Highland Handicraft Guild. "It's on Lodge Street. It's the old Bank Building next to Wayside Grill. The stories I've heard is that the spirit looks like a banker. That bank was only open for only a couple of years, and then the crash happened. There's also some history of crazy stuff that went on there, like a Nazi sympathizer ran like a little printing press there or some kind of paper there. Some of the people who work there say they have definitely felt otherworldly stuff going on."

BEER CITY, U.S.A.

*It was a huge surprise, but looking back, it wasn't a scientific poll. It was a
function of the locals being very tuned in and enthusiastic, so they voted every
which way they could.*
—Oscar Wong talking about Asheville's claim as "Beer City, U.S.A." (in an
Examiner.com poll started by Charlie Papazian in 2009, Asheville tied the first
year with Portland, Oregon, won the next two years outright and then tied in the
fourth year with Grand Rapids, Michigan)*

If there's a rock star in Asheville's craft beer scene, it's Oscar Wong, the
man who opened the first legal brewery since Prohibition in downtown
Asheville in 1994. His wife, however, didn't think he was a rock star when
the business lost money for eight years before finally breaking even. "Do you
know what you're doing?" she would ask the retired engineer.

His perseverance paid off with Highland Brewing staking its claim as not
only the first craft brewery in Asheville but also one of the most popular.
Its seasonal brew Cold Mountain has reached cult status, with fans racing
to grocery stores and local bars when the brew is released each November.

These days, Wong continues to help guide the business, but he's handed
over the reins to his daughter, Leah Ashburn, who now serves as president
of the company after transitioning from positions in sales and marketing
within the company. He disputes being happy about the change. "I'm
not happy, I'm *ecstatic!*" he said from the offices at Highland Brewing on
Old Charlotte Highway in East Asheville. "I will be here as much as she

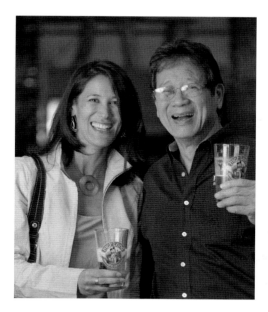

Leah Ashburn and Oscar Wong of Highland Brewing. *Highland Brewing.*

would like. I'd like to come in here for quite a while. I'll be her mascot."

The company has just doubled the square footage of its production facility in East Asheville, and there are plans for a rooftop bar and garden. Wong said that he never expected the craft beer scene to grow so big. "I envisioned a town like Europeans have, where you have two or three breweries, and if you come to town you are offered one of those," said Wong. "There are sixteen breweries now in Asheville, and within the county there's about twenty and more on the way. It's crazy. This is not what I expected. Nor did I expect the big guys to come in. That really changed the trajectory of what we had in mind. And that's something more suited for Leah to come in and pick up and run with. It's a young people's game."

Ashburn said that the great thing about Asheville's craft beer scene is the high level of collaboration and cooperation between breweries. "There's an Asheville Brewers Alliance that's been around for years. Our brewmaster, John, has been president several times," said Ashburn. "There was recently a two-day malt conference here at Highland—150 people from ten states came and lots of folks from Asheville. People get together and really work together on collaborations and talking about best practices and education. I think everybody sees if we all do well, ultimately wouldn't it be incredible if people say, 'Have you been to Asheville?' just like they say, 'Have you been to Napa?'"

"We've helped a lot of the breweries that got started," added Wong. "We recognized that if there are breweries here that don't do a good job, it reflects on the whole category. You don't want to be the best among bad folks. You want to be the best among really great folks. People who come from other places are surprised at the level of collaboration in Asheville and the way we work together. We compete, too, but at the same time we collaborate."

Asheville's Pubcycle is a fun way to travel to different breweries. *Photo by Marla Milling.*

Likewise, it's not just collaborations among similar businesses but rather the blending of all the businesses that create the vibrant attitude in Asheville. "They all come together—art, music, libations and food. It built on what Biltmore and Grove Park Inn had and took it to another level," said Wong.

CREATIVE FLAVORS

With a growing number of breweries in Asheville, the name of the game is being creative. Experimenting with different flavor combinations is a continual process, and some are offered one time only. At Asheville Pizza & Brewing Company, the brewmaster has used pumpkins and coffee flavors in the beer, as well as a cilantro and lime variety, to celebrate Cinco de Mayo. He's adding watermelon to the Rocket Girl brew in the summertime, and they have collaborated with a brewery in South Bend, Indiana, to create Evil Ninja Porter featuring the Carolina Reaper pepper, which is among the hottest peppers in the world. They take out the parts of the pepper that are really acidic and then add to the beer to make a fantastic drink with a kick. This variation on Asheville Brewing's staple beer, Ninja Porter, is just one

of nine in a special Ninja series that will be brewed in 2015 in collaboration with other breweries.

"The amazing thing about Asheville is you can go out and find roughly two hundred fresh beers, and half will never be seen again," said Mike Rangel. "People are like, 'Did you try that beer at Wicked Weed last week? Well it's gone. It was a one-timer.' It becomes legendary. If you're a beer lover in this town, you are absolutely spoiled. The beer IQ of the average citizen in Asheville is through the roof."

Rangel and his ex-wife and current business partner, Leigh Lewis, started Asheville Pizza in the late '90s in the former Two Moons Brew and View on Merrimon Avenue. The brewmaster for Two Moons stayed with them and became a partner, but beer making hadn't been on Rangel's agenda. "Admittedly, I was not a beer fan at all, but I had never delved into craft beer," he said. "I grew up in Kentucky, and bourbon was what you drank."

Now his business is a major player in Asheville's craft beer industry, churning out forty to fifty new beers per year. The most popular of their regular varieties is Shiva IPA. Rangel never expected the explosive growth of Asheville's craft beer industry and believes it's tied to the food movement, which has also gone off the charts. "I think anywhere you find

Cans of Shiva at Asheville Brewing Company. *Photo by Bren Photography.*

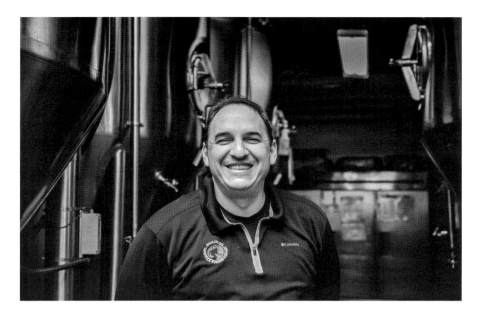

Mike Rangel, co-owner of Asheville Brewing Company. *Photo by Bren Photography.*

a craft beer town you'll find a foodie enclave there beforehand," he said. "When a population is involved in farm-to-table dining, locally sourced ingredients—when you're paying attention to what chicken you're eating, the natural progression is to do the same for beer and wine too."

He also gave credit to the community spirit in Asheville, where people support one another and go out of their way to help out in any way they can. He uses the phrase "beer with a conscience" to describe how he will donate proceeds from special beer runs to benefit an organization or charity. They recently brewed an Asheville United beer and donated one dollar for every pint sold. The beer sold out in nine days. Another promotion included crafting a beer to celebrate the tenth birthday of one of the wolves at the WNC Nature Center and then donating proceeds to the Wolf Habitat there.

"Asheville is magical, supportive and creative," he said. "It's a mixture of incredible individuality and talent mixed with a way above-average sense of community and sense of 'live and let live.' If you want to wear a ballerina costume downtown, that's great. I may have on a unicorn head and go skateboarding." He said he gets a kick when family or friends from out of town come to visit and react to some of the unusual, weird sights downtown. "They'll say, 'Did you see that nun on the bicycle?'" he said.

Asheville Pizza & Brewing Company also ranks high as one of the most popular, family-friendly places in Asheville. The Merrimon location offers great food, a full bar, three-dollar movies and a big dining/game room with funky murals painted on the walls, big-screen TVs and video games. The Coxe Avenue location doesn't have the movies or games but still provides a fun atmosphere. A third place in South Asheville offers takeout, and then there's the Millroom—event space on Ashland for any type of funky, weird event (or normal event) that one can dream up.

THE BEAT GOES ON

This is some of the wisdom I've picked up by playing with older cats—if you can land at least one or two weekly gigs, sort of your bread and butter, then you're free to go and do other things that may not pay as well. You can take risks.
—Aaron LaFalce

Asheville singer/songwriter Aaron LaFalce believes the popularity of craft beer in Asheville wouldn't be as strong without an equally strong music scene. He's been in Asheville his entire life and has watched the music scene expand into a place that offers him the unique opportunity to make a good living doing what he loves.

"I think you can probably attribute most of the beer making business in Asheville to the vibrant music culture here," said LaFalce. "When people go out drinking, they want to hear good music. There's something about the music here that is very organic, and it does mirror the natural environment. Just as you listen to certain styles of music and you can almost feel the environment through the tone of the song and through the lyrics, the same is true for beer. When you drink beer, you're tasting the environment. You're tasting stuff that was grown in a certain region. You're ingesting it. I definitely see a parallel in how they work and how people enjoy them. Music is like beer to the ears."

LaFalce started playing when he was about thirteen years old, but music is in his blood. His grandfather, from New Jersey, was playing with a big band in the early '50s when they stopped in Asheville for a week to play at

Singer Aaron LaFalce. *Photo by Hannah LaFalce.*

the old city auditorium, which is now the Thomas Wolfe Auditorium at the U.S. Cellular Center. He met an Asheville girl, and after they married, they settled in Asheville and he became part of the Paul Nichols Orchestra. He played saxophone and arranged the horn parts.

LaFalce's dad went to Asheville High School and was also a musician, songwriter and guitar player. At Reynolds High School, LaFalce joined the choir program and also worked on his musical skills and songwriting. "I was exposed to the classical music of the school system, my dad's rock and classic rock background, my grandfather's big-band jazz background and also the mountain music of the time. As a city kid, I was also exposed to urban music. The influence of all that shaped me into the style I have today."

He was part of a band during his high school years called Awkward Pause, and they had a chance to do some gigs as the opening band for Grand Torino, based out of Knoxville. "It was right at the tail end of Be Here Now and before the Orange Peel," said LaFalce. "There was a venue called Asheville Music Zone that was open for a few years. It's where Olive or Twist is now at the corner of Broadway. I look at that era as the bridge between the old Asheville music vibe and what's happening now. It was happening right at the revitalization of downtown."

The exposure changed his life and fueled his passion for playing in public. "Girls were asking for my autograph, and I thought, 'This is bizarre'—to go from a kind of a geek as a kid to all of a sudden girls are paying attention and I'm doing what I love, which is music. So that was my introduction to gig life."

Another big development came when he started playing at Open Mic Night on Mondays at the Hangar on Airport Road in South Asheville. He got to know the guys in the house band, some of the busiest musicians in town. "They were the guys who played everywhere—members of the Caribbean Cowboys; Steve Weems; Johnny Blackwell; Matt Sluder, who grew up with Warren Haynes; and Steve Barnes, who also grew up with Warren. I started hanging out with these guys who were twenty to thirty years older than me and really developed my chops playing with them. When I started the Aaron LaFalce Band in my early twenties, I would hire some of those same guys to back me up."

Other gigs included two years playing piano weekly at Vincenzo's Piano Bar, as well as playing in the house band at Magnolias. He also performed in 150 shows during a season working at Carolina Nights dinner theater in Maggie Valley.

Today, he's built a solid career as a solo artist and has a regular weekly gig at 131 Main in Biltmore Park, as well as regular bookings at Cedric's Tavern and Deerpark on the Biltmore Estate and at the Grove Park Inn. In addition, he serves as a popular midday host on 98.1 FM The River and worship director at Seacoast Church. He and his wife, Hannah, are expecting their first child this year.

DISCOVERED TALENT

Warren Haynes is one of the biggest music success stories out of Asheville—not only for building a successful career but also for what he gives back to his hometown. Haynes, an Asheville High graduate, created an annual Christmas Jam that showcases a wide variety of popular singers and bands. They all donate their time to raise money for charity. Proceeds from the jam go to the Asheville Area Habitat for Humanity. According to a report in the *Asheville Citizen-Times*, Haynes presented a check to Habitat for $500,000 in July 2014, bringing total gifts from the jam to $1.8 million.

Haynes began his rise to fame when he was discovered playing at a small bar in Asheville—a story that LaFalce says is really amazing given that Asheville was a much smaller town then and didn't have the benefit of the Internet or social media, which are often helpful to rising musicians today. "The way I hear it is that he was playing at the Brass Tap on Merrimon Avenue, and David Allan Coe's band was in town. I believe some members from his band discovered him playing in the bar, and one thing led to another," he said. "The next thing you know, he's on the road playing with that band, and that opened all the other doors for him getting into Nashville."

Haynes went on to become a longtime guitarist with the Allman Brothers Band, and he founded his own band, Gov't Mule.

Caleb Johnson is another Asheville native who's making his mark on the music world. Johnson, a graduate of Erwin High School, claimed the title of "American Idol" in 2014. His hometown visit included a short concert at the Orange Peel and the Emerald Lounge on Lexington Avenue. He also played a concert in November to a sold-out show at the Orange Peel, much to the delight of his hometown fans.

The Orange Peel was serving as an auto parts warehouse when Julian Price restored it and turned it into one of the top music clubs in the country. *Photo by Marla Milling.*

"Three or four years ago, Caleb and I auditioned together for *American Idol* in Austin, Texas," said LaFalce. "I was hosting a jam night he was coming to because he was fresh out of high school. I was telling him, 'Dude, you need to go for it.' At the same time a local business contacted me and said, 'If you go to the audition, we'll fly you out to Austin.' We actually met up for dinner one night, me and Caleb and his mom."

"Asheville is still a small town," he continued, "and there aren't as many opportunities here, but with the opportunities we have, combined with the Internet, up-and-coming musicians in Asheville have just as much of a chance as anybody else."

In Asheville's future, LaFalce hopes that someone will open a venue that's the next step up. Something that can seat two hundred to three hundred people and offer incredible sound like Oven's Auditorium in Charlotte or Variety Playhouse in Atlanta.

"Not to take anything away from the Orange Peel," he said, "but I think there's another caliber of player that we don't appeal to as a town because the U.S. Cellular Center wasn't built to be a concert hall and doesn't sound that good. I'm big into alternative music, but I also love Bruce Springsteen and U2, and I'd love to see artists of that caliber come to Asheville."

A Nod to Moog

It would be difficult to highlight Asheville's modern music scene without mentioning Bob Moog, creator of the Moog Synthesizer. Born in New York City, he spent his later years in Asheville. He moved to the area in 1978. Today, his company, Moog Music, continues his legacy with continued production of his products and tours of the facility. His creations have definitely had a heavy impact on the music world. Musicians who use his products include a virtual who's who list, including the Beatles, the Bee Gees, Radiohead, Linkin Park, Coldplay and on and on.

"I think Bob Moog was brilliant," said LaFalce. "I think it's awesome he spent so much time here, and it draws attention here. My principal instrument is keyboard/piano, so I'm all about synthesizers. I think all that's brilliant."

MoogFest, a five-day festival that last ran in 2014 in Asheville, seems destined for another location as producers look for a more lucrative way to run the festival. Plans were already in the works to skip the festival in 2015

and bring it back in 2016, but it looks as if it might wind up in a place like Durham and not return to Asheville.

"My understanding is it didn't do so well here, and that didn't surprise me," LaFalce added. "I have an appreciation for electronic music, but it's a fringe genre. I don't think it exploded the way folks thought it would, and that's okay. It's the same thing with Bele Chere. I wasn't sad it was discontinued. I was more sad that it had gotten off track. I don't think Bele Chere is needed anymore because it was started to bring people downtown."

FOODIE PARADISE

All of us in fine dining owe Mark Rosenstein a lot of praise. He opened Market Place restaurant on Wall Street in 1979 and was the first I can remember who opened that kind of restaurant in Asheville.
—Sandy Waldrop, co-owner of Grovewood Café

The restaurant scene in Asheville has become a foodie paradise that rivals much bigger cities. Chef Katie Button, owner of Curate and Nightbell, has become a star, but she's not the only one. In February of this year, Button and two other Asheville chefs claimed three of the nominations for the James Beard Award semifinalists for Best Chef Southeast. She joins John Fleer of Rhubarb and Merherwan Irani of Chai Pani and MG Road. At the time of this writing, Fleer moved to a finalist spot.

Asheville's strong supportive community of chefs and cutting-edge restaurants is tied together by the Asheville Independent Restaurant Association (AIR). Sandy Waldrop, who owns Grovewood Café with her chef husband, Larry Waldrop, said that AIR is a big boost because there's a lot of collaboration and support among the restaurants. "If we see that we're not the right place for an event or we're full on a night, we suggest other AIR restaurants," said Sandy. "If we are suggesting somewhere, it's another independent restaurant."

Asheville's love of food starts in the fields of area farms. This is a town that embraces organically grown products, tailgate markets and restaurants serving farm-to-table creations. On any given Saturday morning in Asheville,

you'll likely rub shoulders with restaurant owners and chefs as they head to area farmers' markets to scoop up fresh ingredients for the meals they'll serve later in the day. "We buy weekly from the farmers' market and tailgate market," said Sandy. "We also use products from area farms like Ivy Creek Family Farm, Hickory Nut Gap Farm, Sunburst Trout Farms and Three Graces Dairy."

Both Sandy and Larry are natives—Sandy grew up in South Asheville, and Larry is from Weaverville. They met on a blind date and have one daughter, Hunter. Larry graduated from the culinary program at AB-Tech and spent ten years at Asheville City Club and seven years at the Piedmont Club in Spartanburg. In 1994, they opened Grovewood Café, which is located beside the Grove Park Inn. During the process of writing this book, Grovewood Café closed in March 2015 after a very successful twenty-one-year run.

"My theory is Asheville has always been a weird place," said Sandy. "I have always said Asheville has always been a welcoming place not so much because we are progressive but because people have always lived such a hardscrabble existence they didn't have time to worry about what other people think."

Sweet Treats Success Stories

There are many food-related success stories in Asheville, but there are two eateries in particular—both catering to the dessert market—that have some big similarities. Both are led by young couples who have true passion for what they are doing. They are hands on and fuel their businesses with love and excitement, but they also recognize the importance of being fully connected to the community and building and strengthening connections there. Both companies have grown beyond the owners' wildest beliefs, and there's no limit to where they'll expand in the future. These two businesses include the Hop Ice Cream Café, owned by Greg and Ashley Garrison, and French Broad Chocolates, owned by Dan and Jael Rattigan.

The Hop Ice Cream Café

Sometimes it seems like Greg Garrison has a clone. Stop in at the Hop Ice Cream Café that he owns with his wife, Ashley, and you will run into him

there—whether it's the location on Merrimon Avenue, Haywood Road in West Asheville or the new Hop Ice Creamery, also in West Asheville. Go to the Orange Peel to catch a show, and he's often there scooping up ice cream. Go to a special event, concert or show at the U.S. Cellular Center, and he's there, too. Head to a festival like Big Love or Big Crafty or Brewgrass or Shindig on the Green, and yes, there's a good chance you'll see him. Of course, he has employees who man these booths as well, but it's incredible how many times he will be running a booth in so many different locations.

While he's prolific in building relationships, handling the marketing, special events and wholesale accounts, Ashley is equally prolific in ice cream production and coming up with unique flavors. They are making new flavors on a weekly basis and rotate them. A sampling of flavors includes bestseller

Ashley, Finn and Greg Garrison. *Photo by Micah MacKenzie.*

Salted Caramel, Beet Swirl, Peach Cobbler with Corn Biscuits, varieties featuring local craft beer, Dracula's Blood, Nutella and even a concoction called Unicorn Poop.

"I keep notebooks, and I have pieces of paper with flavor combos," said Ashley. "If I'm out somewhere at a smoothie bar or a restaurant that has a cocktail menu, I see what other people are pairing together. I read articles online and think about what I like to eat. It's about finding the perfect marriage of flavors."

Locals as well as tourists all scream for the Hop's flavors, and there's been quite a bit of national attention, with *Saveur* magazine naming the Hop's Blueberry Kale flavor as one of "5 Great American Ice Creams," the *Huffington Post* and *Domino* magazine giving the business a nod as one of the "12 Best Ice Cream Shops in America" and the Cooking Channel show *Unique Sweets* featuring the Hop in a segment on "Awesome Asheville Sweets."

Their homemade ice cream brings lots of smiles, especially since they offer a choice for just about everyone, from dairy to vegan to sugar-free to gluten-free options. They also bring smiles with their genuine warmth and friendliness to everyone they encounter. The equal sign on Greg's arm is more than just a tattoo. It's how they both run their businesses and their lives—embracing equality and treating everyone with the same respect.

Greg and Ashley met in a Houston, Texas high school, and he refers back to those high school days when describing how their business philosophy has organically taken shape:

It's all about relationship building and being friends with a bunch of different people. There were always a couple of people in high school that would be friends with athletes and punk rockers and art majors and just everyone. Ashley and I both didn't shut anyone off. I'm a math guy, so there was a whole group of math people in high school who were weirdos because they liked math. I also played soccer, so there were the athletes. I liked certain kinds of music, so there were those people. That's what we were prone to do anyway—just have fun, be happy and surround yourself with good people. It's not a surprise that this also happened with the business. We're friends with the beer people and the doughnut people and the cupcake people and the restaurants and schools. Through social media, we met all these business owners and other folks and said, "Hey, let's hang out. What can we do together?" That's what was appealing about Asheville in the beginning. All of the things people like about Asheville are what drew us here and what we hope to perpetuate with the business.

Unicorn Poop ice cream, served up at the Hop Ice Cream Café. *Photo by Greg Garrison.*

"Ice cream is a wonderful thing that everybody can get on board with," Ashley said. "It doesn't pigeonhole us. We can go to Cabarets and scoop ice cream. We scoop at weddings. We scoop at funerals. We do bar mitzvahs. We do break-dancing shows."

They also give a lot back to the community and offer fundraisers at least two times a month, most often at the Merrimon location. They give half of their proceeds during a set time frame to area nonprofits and other organizations. "It feeds itself constantly," said Greg. "You give it and people give back and you give back. It's nice that can exist like that in a business world."

Ashley and Greg both worked at the Hop when they were students at UNCA. Originally opened in 1978, it was housed in a former gas station

in the Woolsey Dip section of Merrimon Avenue that now operates as YOLO frozen yogurt. The business moved just up the road to 640 Merrimon Avenue in 2007. When the owners put it up for sale, Greg and Ashley worked hard to get financing in order to buy the business and launch their dream. They opened for business in August 2008 and expanded to include the West Asheville location in October 2010. The Creamery debuted in January 2015. They now produce all of the ice cream for the West location, special events and wholesale accounts at the Creamery. Production encompasses about five hundred gallons per week in the winter and one thousand gallons per week in the summer. "There's a lot of ice cream making going on," said Ashley.

French Broad Chocolates

When Dan and Jael Rattigan relocated to Asheville after owning a restaurant in Costa Rica, they initially envisioned running a small business out of their home, and they did for a while. They created savory chocolates in their West Asheville kitchen and sold them at the farmers' market at the French Broad Co-Op. They quickly learned that the demand for their products would support having a traditional storefront operation, so the next year, in 2007, they opened the French Broad Chocolate Lounge on Lexington Avenue. It quickly became a favorite among locals and tourists alike, and as they grew, a line often snaked out of the establishment, causing some concerns by the city fire marshal. In 2012, they opened a chocolate factory on Buxton Avenue, and the day after Thanksgiving 2014, they relieved the fire marshal's concerns about their Lexington Avenue venue by moving to a very prominent spot taking over the Legal Building on Pack Square.

Now all on one floor, the Chocolate Lounge can accommodate 225 people as they enjoy a variety of chocolate treats. They also have a boutique shop, with its own entrance, where people can pop in for hot chocolate, coffee and ice cream to go. As to when and how they'll continue to expand, Jael said, "The potential really is endless."

The couple met in Jael's native Minnesota when both were focused on graduate school—Dan, originally from Pennsylvania, was in law school, and Jael was in business school. The programs didn't seem consistent with their mutual dreams, so they dropped out. Jael had already signed up for a business seminar in Costa Rica. Even though she left the program, she still had a plane ticket to Costa Rica, so she used it. Dan followed her there a few days later.

"We ended up visiting this small Caribbean town on the southern coast of Costa Rica," said Jael. "We fell in love with it. It's a really sweet community and has a similar energy to Asheville because people go there and they just don't want to leave."

They opened a restaurant and began serving up breakfast, lunch and desserts. They bought chocolate from local farms for use in their decadent sweet treats. "That's where the chocolate spark ignited," explained Jael. "It turned into a full-blown passion that Dan and I both decided we would spend our life devoted to."

After two years, they decided they wanted to move closer to family, and they began sharing

Dan and Jael Rattigan. *French Broad Chocolates.*

their vision of the place they were looking for. Over and over, people said, "You guys would love Asheville."

They had driven a school bus from Minnesota to Costa Rica and parked it outside the restaurant, using it as a guesthouse. When it came time to leave, they got back on the bus with their kid and drove it to Pennsylvania, where Dan's family lives. They soon paid a five-day visit to Asheville and adored the surrounding mountains, proliferation of farmers' markets and families they spotted with "dads carrying kids on their shoulders." In about a month, they relocated to Asheville and began making their mark.

"We had our beginnings in Asheville at the farmers' market. We were creating all these amazing relationships with all these local growers and producers and buying local produce and turning it into chocolates and desserts. We loved building that connection, and it became more and more a part of our mission and our value system," said Jael.

"We had a moment where we looked at our chocolate, which we were buying as an ingredient as most chocolate and dessert companies do, and

realized we didn't have a connection to the source of the chocolate at all. That was the impetus to making our own chocolate and building our factory. We are now directly sourcing cacao from farmers and cooperatives in cacao growing regions of the world."

When asked how much chocolate they make, Jael leans across the table and almost whispers, "A lot. It's a lot." This year, they are projected to produce about eighteen tons of chocolate, and of that, twelve tons will be used for products served in the chocolate lounge. They also make chocolate bars, which they sell across the country. Increasing chocolate production is definitely in the cards as they shape future goals. "We're saying no to a lot of people who want to sell our chocolate or use it in their restaurant," she said. "We can't make enough to support everyone who wants it. Growth in our factory production is imminent."

Jael and Dan love being hands on in their company and appreciate the connections they have in Asheville. They continue to make chocolate, help customers, tweak the system and plan for the future. "The personality that is being created by the people who come here and the people who were already here making Asheville what it is—we see that as a collaborative, connected community of people who want to support one another so it doesn't feel threatening. It feels like you are loved and supported instead of feared as competition or a threat. We're doing our part to keep that alive."

BLUE RIDGE FOOD VENTURES

Lusty Monk Mustard, Buchi Kombucha and Fire from the Mountain hot sauces and salsas—these are just a few popular specialty items that got their start at Blue Ridge Food Ventures on the Enka Campus of AB-Tech. It officially launched in 2005, and so far, more than 250 businesses have been launched from there.

When AdvantageWest got the idea to create this food business incubator, it didn't fully see how popular it would become. "One of the ideas they had is that it would be a place where farmers could produce value added products," said Kathi Petersen, senior VP of AdvantageWest. "Instead of just going to a tailgate market and selling tomatoes out of the garden, they could make a product with the tomatoes that could be on the shelf to improve their revenue. What no one really anticipated is that it would be a place where specialty producers of artisanal foods would use it."

The owner of UliMana Chocolates was one of the first to embrace the incubator opportunities. Theresa Green started small and ultimately built a national following. She continues to produce her products at Blue Ridge Food Ventures today. "She got the idea of using raw chocolate to make truffles," said Petersen. "At that time, people who were on a raw food diet didn't eat chocolate because chocolate is normally roasted. She made a spread and took samples to a natural foods expo."

When she got a quick 250-jar order from one person at the expo, she knew she needed the right facility to work in. Blue Ridge Business Ventures has eleven thousand square feet of shared-use commercial kitchens. It offers a wet kitchen area, where items like salsas are prepared, and a dry kitchen for things like baked goods. Customers rent by the hour and can also rent a cage or pallets to store their ingredients. "Unlike a traditional incubator, where there is a fixed period of time and then you graduate out of it, that's not the case here," said Petersen.

Blue Ridge Food Ventures also has the unique distinction of being the only facility in the country to offer shared-used GMP-compliant natural products manufacturing. Petersen said this means that customers can produce such things as medicinal herbs, dietary supplements, natural cosmetics, extracts and tinctures. One product using locally grown goldenseal was produced at the facility for use in drug trials conducted by the National Institutes of Health in Bethesda, Maryland.

SPREADING THE LOVE

I never intended to start a community organization. It was truly grass-roots. The community grew it, and I followed along.

—Franzi Charen

Franzi Charen never envisioned herself as leader of a community organization, but now she wishes she could devote her full attention to the grass-roots effort she started in 2009 with the "Asheville Grown—Buy Local" campaign. The overall goal is to put money back into the local economy as a way of keeping Asheville unique.

"It started in a very personal way," said Charen, who owns Hip Replacements at 72 Lexington Avenue. "I got together with a few of my business owner friends, and we talked about a way to create marketing around supporting small businesses who help build and support and keep the culture alive in this town."

When she took some basic posters around to other business owners in 2009, about 60 percent bought into the concept of working together to encourage the promotion of local businesses. "Around Valentine's Day, I had business owners calling me up saying their poster had faded and asking for another. They also said, 'Can you promote shopping local for Valentine's Day?'" said Charen.

That's when she came up with a heart design that read, "Love Asheville. Put your money where your heart is." It resonated with business owners as well as the local community and began spreading on local media and drawing attention in the *Asheville Citizen-Times* and *Mountain Xpress*.

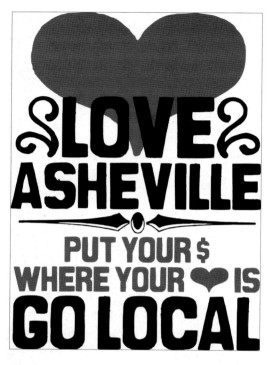

Sign encouraging customers to buy local in Asheville. It's part of the Asheville Grown Business Alliance. *Franzi Charen.*

Today, the Asheville Grown Business Alliance has expanded past posters, stickers and T-shirts to make a real impact on creating funds for education. The Go Local card offers discounts at a variety of local stores and restaurants and was designed as a fundraiser for the Asheville City School Foundation.

"We started the Go Local card in 2012. The City Schools Foundation came to us," explained Charen. "They were selling School Checks, which were checkbooks filled with coupons—most promoted fast-food places and corporate America. It didn't match what they were trying to do in the schools, so they asked us if we could create a fundraiser around local businesses. We thought that was a brilliant idea. They ditched School Checks, and we started Go Local."

Asheville Grown Business Alliance also worked with the organizers of the Big Crafty Festival to create the Big Love Festival. Big Crafty allows artists to participate regardless of where they are from, but there was interest in creating an arts and crafts festival designed to solely promote local artists and craftspeople.

"We did Big Love with them for three years, and last year they did it by themselves," Charen said. She says the new goal for the alliance is to create more conferences, and it also plans to take over the Venture Local Fair.

FALLING IN LOVE WITH ASHEVILLE

Growing up in Charlotte, Charen had exposure to Asheville, but she traveled around quite a bit before settling in town in 2002. She had been

living in Oakland, California, but longed to step out of the rat race and get back closer to family. Her parents are in the Kings Mountain area, and she had a brother living in Asheville when she moved here.

Starting a business in the Bay area or even buying a house seemed like huge obstacles, but Asheville inspired opportunity. "I've always had an entrepreneurial spirit," she said, "and Asheville felt like such a small place and I felt that anything was possible."

She created a business plan through Mountain Microenterprises (now Mountain BizWorks) while waiting tables and bartending. She was involved in several business ventures before buying Hip Replacements. She started out rehabilitating houses but left that business with her

Franzi Charen heads up the Asheville Grown Business Alliance. She's also the owner of Hip Replacements. *Franzi Charen.*

then partner. She worked in the ceramic manufacturing business, sold that and then acquired the business of one of her best customers—Fired Up! Creative Lounge on Wall Street, where customers paint selected pieces of pottery. She ran that business from January 2006 until she sold it in June 2008.

She found out the owner of Hip Replacements was struggling to stay afloat and planning to sell, so Charen took another leap and bought the store. She said that it was somewhat of a fluke that it all fell together— finding out about the chance to buy and then sealing the deal in September 2008, a time when the economy was starting to tank.

"I had traveled so much over the U.S. and Canada. I realized how special Asheville is," Charen said. "So many towns were becoming homogenized, with chains taking over. Downtowns are becoming 'Anywhere, U.S.A.,' with the local culture disappearing. When they were talking about Urban Outfitters coming into Asheville, I thought, 'Are we on a path to becoming

like every other city?' I really began to fall in love with Asheville and the opportunities and people who helped me along the way."

Her love for Asheville fuels her passion for growing the Asheville Grown Business Alliance.

GROWING THREATS

While Charen loves and supports Asheville's growth, she also worries about its future and knows that the time to take action is right now. She said that many of the people who worked tirelessly to renovate downtown and invited in unique businesses—like Julian Price and John Lantzius—are now gone. Other building owners are aging, and it's unclear what will happen to their properties if family heirs don't feel the same love for Asheville.

"If we haven't passed the tipping point, we're right there," she said. "There's nothing in place to preserve and build Asheville in a healthy way. The more tourists who settle here and the more money that comes in, the more we as a city will look at what their tastes are and what they think Asheville needs."

She used a recent visit to an area tailgate market as an illustration. A friend introduced her to a woman who had just moved to Asheville from Atlanta. The woman gushed about Asheville's uniqueness, and Charen shared her work on promoting local businesses. Then the woman said she waited until Trader Joe's was built before moving to Asheville because she couldn't live without Trader Joe's close by. This desire for more chain stores is something Charen worries about. "Why do you need a Trader Joe's when we have the French Broad Co-Op?" she asks. "Some people have the attitude of, 'Oh, if only Asheville had a Gucci store downtown then I would move there.'"

"As connected as I am, I have a three-year lease, and if Anthropologie wants my space, there's nothing standing in the way of Hip Replacements being kicked out three years from now. That's how fragile this all is. We're all in this together. If we don't want that to happen, what are the steps we take to prevent that? There are ways to make some of the right steps happen, but it takes courage."

She's currently researching how some cities in Utah have gotten together with the banks to create an incentive package to sell to independently owned businesses. It's one way to keep downtowns unique and alive. "If I owned my

property and I run my business, I'd be much less tempted to rent to someone else," said Charen.

When the Asheville Downtown Association recently asked Charen how to support local businesses, she threw out a crazy idea—Asheville has been built on many crazy ideas for decades. "I said, 'What if we were nuts enough to shut down the Tourism Development Authority and pull all the money that goes into tourism and reinvest it into ways that help the local population—things like affordable housing, job training, farming, etc. You will create an interesting, welcoming place. If we focus on what the locals want, the tourists will come anyway.'"

FUNKY ASSORTMENT

For the moment, in downtown Asheville, the stores, restaurants and galleries are primarily unique, independently run and feature all kinds of items, from weird and quirky to colorful, artistic, functional and necessary. Here's a quick, random look at some of the shops that make downtown so unique, eclectic and funky.

Instead of chain stores invading downtown, Asheville still has a healthy population of unique, colorful stores like Kim's Wig Center. *Photo by Marla Milling.*

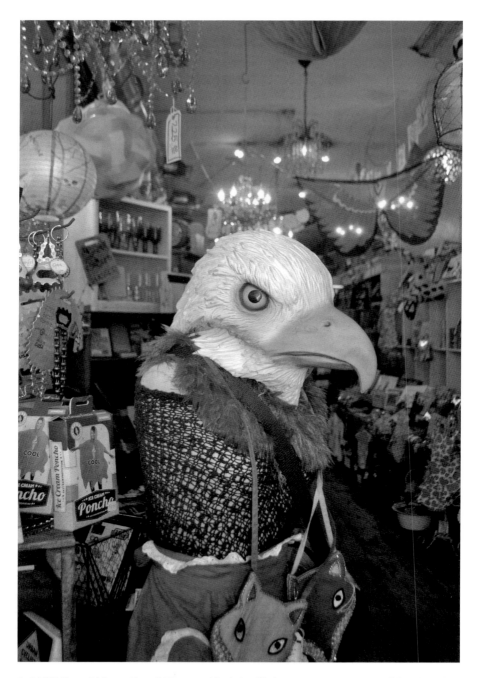

L.O.F.T. (Lost Objects, Found Treasures) in Asheville has an amazing range of fun, fanciful and funky items for sale. *Photo by Marla Milling.*

ASHEVILLE BEE CHARMER—A honey tasting station beckons to those who enter this Battery Park Avenue shop that has beeswax candles, T-shirts, skin care products and more.

INSTANT KARMA—Want a "Keep Asheville Weird" sticker? This is the place to find it. The store at 34 North Lexington overflows with bumper stickers, T-shirts, incense, glow-in-the-dark tapestries, candles and scarves, just to name a sampling of the inventory.

Deborah Coule, owner of Chevron Trading Post & Bead Company, hugs her lab, Millie. Millie has been coming to the store with Coule for years and even takes part in kids' birthday parties held there. *Photo by Marla Milling.*

Truly Ball, co-owner of Nest Organics on Lexington Avenue, holds Nico, a dog that belongs to her daughter and business partner, Sarah Easterling. *Photo by Marla Milling.*

L.O.F.T. (Lost Objects, Found Treasures)—You can't miss this place, with its colorful whirligigs and other traffic-stopping items on Broadway. Venture inside, where the shop is jam-packed with things you'd never believe if you didn't see them: candles designed to smell like different Asheville neighborhoods, inflatable unicorn heads for your wall, sassy magnets and even some X-rated unmentionables. Say hello to Louise, the shop parakeet. Her cage is strategically placed near the cash register.

Street Fair—Get ready to have your mind boggled with an amazing inventory of earrings, flowing skirts, scarves and other items. You won't believe the abundance of choices in this colorful shop.

Zapow!—Over on Battery Park Avenue, this gallery has some of the funkiest, most out-of-the-box art you'll find in Asheville. The delightful, ever-changing inventory focuses on illustration and pop culture art.

Animal Love

Asheville is a town that truly loves its pets, and some of these four-legged friends are gaining a bit of extra attention and fame for helping their owners

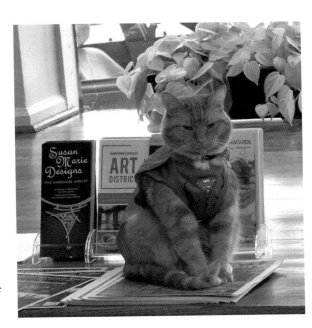

Charlie the cat in one of his many costumes at Susan Marie Designs on Biltmore Avenue. Charlie has such fame that he has his own Facebook page. *Susan Marie Designs*.

run the stores. There's a white lab named Millie who greets customers daily at Chevron Trading Post & Bead Company at the corner of Lexington and Walnut. The shop is very recognizable with its smorgasbord of brightly colored star lamps in the windows. Chevron rents out space for kids' birthday parties, and Millie loves to take part. Owner Deborah Coule will put a party hat on Millie's head and let her join the guests.

Down at 51 North Lexington at Nest Organics, Nico has been spending time in the store and eating up the attention from customers. Co-owner Sarah Easterling adopted Nico from Brother Wolf Animal Rescue in Asheville. She runs the store with her mother, Truly Ball.

A shop cat in a Biltmore Avenue store has become so famous that he has his own Facebook page. Charlie the cat is the pet of Susan Phipps, owner of Susan Marie Designs, a showroom of exquisite handcrafted jewelry. Charlie has quite a few costumes that he wears. They change depending on the season, but the Superman outfit is a favorite.

Battery Park Book Exchange & Champagne Bar in the Grove Arcade is another place you'll find dogs. Owner Thomas Wright invites customers to bring their dogs inside with them. This space holds thirty thousand books for sale, along with cozy seating arrangements and a bar serving up wine, champagne, coffee and treats.

WEIRD WEST ASHEVILLE

To me, West Asheville is the late-blooming younger teen brother of Asheville.
—Zen Sutherland, photographer and West Asheville resident

W orst Asheville" once served as the negative catchphrase for West Asheville. Those days are gone, as it has definitely come of age with its own brand of funky individuality. It's far enough away from downtown to have the feel of a separate town, yet it is still a part of the whole. The continual expansion of the River Arts District corridor will be key in future years to tying West Asheville more efficiently to downtown.

West Asheville explodes with restaurants, nightclubs and hipsters. As Lexington Avenue (once the freakiest part of downtown Asheville) becomes more gentrified, those seeking a more cutting-edge environment are heading into West Asheville. This area is a bit grittier and caters a great deal to the hipster crowd. You'll see a lot of beards here; edgier nightclubs; funky coffee shops like Battle Cat, which serves up a Pimosa (hipster favorite PBR mixed with mango juice); and a lot of individuality among people strolling the streets.

Gary Charles, owner of G Social Media and AskAsheville.com, is also a West Asheville resident who has a good take on what's happening and dubs the west side as "Best Asheville." "West Asheville has a lot of the same mentality that got downtown Asheville started—people coming to a community and bonding and joining hands," he said. "When I say 'West Asheville Best Asheville,' it's about taking pride in a community and where it's headed and where it's come from."

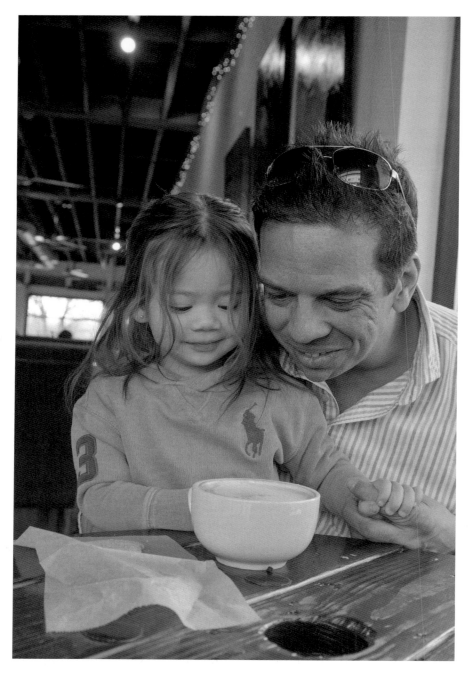

Gary Charles, owner of G Social Media and AskAsheville.com, takes a break at Odds Coffee Shop in West Asheville with his little girl, Gigi. *Photo by Adrian Etheridge of ASE Photography*.

Charles grew up in Brooklyn, the son of two firefighters. His mom was one of the first female New York City firefighters. He's lived now in Asheville for twenty years. "They claim West Asheville is the Brooklyn of Asheville and even the Brooklyn of North Carolina," he said. "I haven't had this sense of community since I moved from Brooklyn. When people come to a community, they look for a place where they can group and connect. I can walk Haywood Road in West Asheville and wind up with great experiences everywhere I go. There's a great walkability factor here. People can park and walk to the end of Haywood Road and back. It's all going to fill in here quick."

ROMP

If you park in West Asheville, you might find a gift on your car when you get back. West Asheville resident Zen Sutherland creates an eclectic mix of spray-painted and handcrafted car magnets featuring "WAVL" amid a variety of colors, stripes and images. He spreads the love by putting them on cars or any metal object in West Asheville. He calls the project "ROMP,"

An assortment of ROMP magnets created by Zen Sutherland. *Photo by Zen Sutherland.*

which stands for Random Oval Magnet Project. There's even a Facebook page for ROMP where people can post photos of the magnets spotted on cars around town.

One of the coolest things about this project is that it's entirely free and fun. You can't buy one of these magnets. If you're not lucky enough to find one on your car, you can connect with him through the FB page and request one. "Because they are easily removed, I encourage people to swap and take the magnets and place them elsewhere (like on your own car) or on your refrigerator…You or your cars are the gallery for a constantly shifting work of art that is ever-changing and moving," Sutherland wrote on the ROMP Facebook page.

BUFFALO NICKEL

The upstairs of two buildings on Haywood Road sat dormant for years—a time capsule of sorts holding salvaged timber that had been stripped out of a leaking roof.

Today, that space is one of the most hopping, exciting places to go. It's part of Buffalo Nickel restaurant. After climbing the staircase, you are greeted by the expansive brass bar, with the bottom crafted from recycled doors; customers round the corner to see a gigantic game room space including pool tables, seating areas and video game machines. The first word that comes to mind is, "Wow!" "Everyone says that when they come up here," said co-owner Lynn Foster.

Her husband, Rob Foster, bought the dilapidated building twenty-nine years ago. At that point, the community was petitioning for it to be torn down, but Rob repaired the trouble spots and ran his business, Blue Ridge Restaurant Equipment, for ten years in the downstairs space. In another time, the buildings (747 and 751 Haywood Road) served as May's Meat Market and Grocery Store.

His inclination to save the salvaged lumber really paid off when he and Lynn decided to create Buffalo Nickel Restaurant. It opened in March 2014. "As I was tearing it apart [twenty-nine years ago], I thought, 'This is perfectly good timber,' so I saved it. It had been sitting up there for twenty-eight years. When we decided to do the restaurant and restore the building, we found a use for repurposing all of it," said Rob.

All of the restaurant tables have been crafted from the vintage lumber, and they used the old heart of pine flooring as wainscoting. The restaurant has a

fun, rustic feel with the use of wildly different chandeliers, buffalo statues (some are gifts from the Buffalo Trace Bourbon for selling so much of its product) and a vintage front door with an inset of stained glass.

West Asheville now rivals downtown Asheville as a foodie paradise. There's a high number of restaurants along Haywood Road, including the Admiral, which has won national attention despite its nondescript outer shell; Sunny Point Café; Biscuit Head; Oyster House Brewing Company; Lucky

Rob and Lynn Foster. *Buffalo Nickel Restaurant.*

Otter; Barleycorn; Nona Mia; the WALK; and King Daddy's Chicken and Waffles, to name a few.

Born in Weaverville, Lynn has lived in the area most of her life, with just a few stints away in her early twenties, but she found that "the pull of the mountains is very strong, and the pull of home is very strong. I love it here."

Rob's life journey took him to places all over the world in his youth, but he's been happy raising a family in Asheville. He and Lynn celebrated their twenty-fifth anniversary on Valentine's Day 2015 and have two children, Sam and Paige. Rob was born in Paris and went to grade school in the Philippines and high school in the Netherlands. His dad opened Social Security offices in the 1930s in Asheville and retired here in 1969. "He stayed about two years and said it was a bit too slow for him," said Rob. "I said, 'You've moved me around my whole life. I think I'll stay here.' I've been here a long time."

Rock Star Chef

Before opening the restaurant, the initial plan included renting the space to another business, but they had to back out because the space was too much to handle. Along with the dining space and kitchen on the main floor and the expansive bar and game area upstairs, there's also a full-prep kitchen downstairs. "Lynn said, 'Why don't we do our own restaurant?' I said, 'Are you sure?'" said Rob. She jokes when recalling her response. "I said, 'It won't be that much work. I'll find a young rock star chef and he'll do everything for us.' But it's a lot more work and a much bigger physical space than I envisioned."

She did find the rock star chef. Ryan Kline sits beside her as she sings his praises. Hailing from Pittsburgh, he arrived in Asheville in 2009 to do an internship at Biltmore Estate. He worked at the Bistro on the estate and then served as sous chef at the Storm Rhum Bar in downtown Asheville. He's won regional accolades for the dinners he prepared as featured chef at several Blind Pig dinners. Also, in 2013, the *Asheville Citizen-Times* named him one of "Asheville's Young Guns: Rising Culinary Stars."

Downtown and West Asheville both play host to an amazing number of great restaurants, but Kline said that the clientele is completely different. While downtown caters to a tourist-laden market, West Asheville is all about the community. "Over here is a local scene for sure," said Kline. "You've got to take care of your neighbors and people who live over here. That took some adjusting, but I think we're pretty well dialed in now."

They listen to what people like and tweak the menu accordingly. Kline described his food as "kicked up comfort food" and enjoys surprising customers with the unexpected—some examples include parsnips with white chocolate, pierogis with handcrafted dough and Kung Pao octopus.

Lots of Changes

When the Fosters operated the retail space of Blue Ridge Restaurant Equipment out of the building in the late '80s, they said it was rare to see someone walking down the sidewalk. Now, West Asheville is packed with people strolling the street, families with baby strollers, people jogging and more.

The town offered most everything residents needed without having to venture too far from home—it had a hardware store, furniture stores,

grocery stores, barbershops, Moody's Jewelry and other businesses. Now they are seeing an explosion in two main areas; restaurants and tattoo shops. "There used to not be tattoo shops along this road, and now I think there are more on Haywood Road than anywhere in Buncombe County. There are a lot of tattoo shops. There are also twenty-seven places to eat on Haywood Road," said Lynn.

"The explosion of restaurants is unbelievable," Rob added. "Also, the numbers of people fixing up their buildings. We've seen a big surge in the past two or three years of buildings being fixed up."

They once had eighteen thousand square feet of warehouse space in the old Chesterfield Mill in the River Arts District. When that burned on April 2, 1995, they moved the entire operation of Blue Ridge Restaurant Equipment to a new location on Burton Street in West Asheville—an area that's also seen some big changes. "West Asheville feels safer than it did thirty years ago," said Rob. "It was pretty rough back then."

GRAB A CRYSTAL BALL

The word is out about Asheville, and new people are discovering this special place that so many already love. Asheville is cashing in on major publicity. But where is the tipping point? How do we protect the things that make Asheville such a unique, quirky, eclectic draw right now and keep that originality from being snuffed out by gentrification? Those are questions that many will ponder in the next decades as Asheville continues to evolve. I asked some of the people I interviewed to reveal their predictions for this town. Here's what they had to say.

LOU BISSETTE: "I think what's happening down at the river will be a major change and it's going to change Asheville a lot for the better. I also think all of these five or six hotels they're building now in downtown will have a big impact. I guess when you're a popular place, there's not much you can do to slow it down."

FRANZI CHAREN: "I think the one thing we do not have in place is a policy to protect downtown or independently owned businesses. I think the misconception is people think Asheville is this way on purpose. It's not. It's a combination of pluck and the fact that we're a progressive town. It grew from artists and risk takers making it an interesting, diverse place that's welcoming to all walks of life. That's what it's organically become. My fear is there's nothing preventing it from becoming 'Anywhere, U.S.A.'"

Spying trees on Wall Street wearing sweaters is definitely an "only in Asheville" moment. Purl's Yarn Emporium temporarily dressed trees, parking meters and benches in October 2014. The yarn bombing celebrated the Craft Fair of the Southern Highlands, held twice a year at the U.S. Cellular Center. *Photo by Marla Milling.*

JOAN ECKERT: "We're seeing a real division between the new Asheville and the old Asheville. New Asheville is so much more modern and exciting, with places like Wicked Weed and Curate and other new businesses. The old Asheville includes places like us [Laughing Seed Café], Barley's, Salsa's—places like that. Do we try to modernize and make it different or keep it the same? I'm more of the mindset to keep it the way it is instead of trying to change it too much or homogenize it."

AARON LaFALCE: "I want people to know I'm an optimist by nature, but there's part of me that's like, 'It's been a great ride.' Part of me hopes Asheville doesn't lose its identity with this growth. There are deep roots here, and for me, that's what makes the town great. It's the fact that you can have the quirkiness and weirdness and then like my friends, who are farmers and very down to earth, old school and conservative—that's what makes Asheville great. It's not that we're liberal. It's that we have both liberal and conservative. It's not that just some folks are very artistic, but also folks who are very linear and mechanical. It's that we have both that makes us great. It's not one or the other. It's both."

AN ECLECTIC HISTORY

TOM MUIR: "It's a common pattern, and Asheville should be looking at other cities that have experienced [a] similar type of evolution. It's not uncommon to see a blighted downtown revitalized because an artists community moved in, and they're there because there's lower, affordable rent. Then their success begins to make it not affordable for them to continue to operate those kinds of businesses in the downtown. They begin to leave. Those that move in are not the kind of businesses that attract the foot traffic and create that same kind of atmosphere, and pretty soon you wind up with a downtown core that is exclusive and [this] makes it difficult for the local community to be part of it. In terms of the Thomas Wolfe Memorial, we're thrilled to see new hotels going into the area. It will increase our visitation. We're here for perpetuity, so we don't face that same situation that a small gallery in downtown will be facing."

APRIL NANCE: "There are things happening in the River Arts District that can enhance the visitor experience, but I hope the young emerging artists will continue to have a place there."

KATHI PETERSEN: "As excited as I am about seeing New Belgium go up and knowing how the River Arts District has evolved over time, I think it's exciting to see it and at the same time it's really scary. I don't think we realize just how much that's going to change things. I know it's going to be beautiful and way better than those half-burnt-down factory buildings that were such an eyesore. It's going to be gorgeous and a great sense of pride and excitement, but I do feel a little trepidation about it."

GRACE PLESS: "I honestly think the people who care about Asheville, and that seems to be an inordinately large percentage, will help it stay and continue."

JAN SCHOCHET: "My mom has always said everything is a pendulum— it goes one way and then it's going to swing back the other way. The Asheville Mall emptied out downtown, and then finally it came back. It was crazy in 2008 with five different projects for twenty-four-story buildings, and then the economy tanked and those things went away. If you look at the population growth projection for Asheville, it looks kind of scary, but you never know what's going to make that change. If there's another downturn, that's going to stop. It would be good to see more affordable housing for the first-time homebuyer. That's one thing that is going to limit how much Asheville grows."

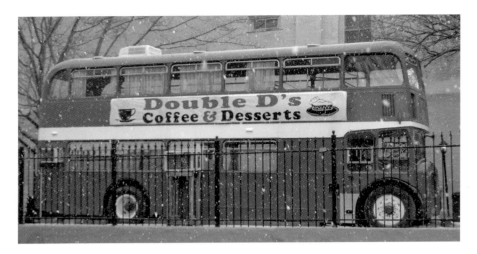

A town of four seasons. Double D's Coffee & Desserts on a snowy February 2015 day. *Photo by Marla Milling.*

MILTON READY: "I do think Asheville is at another one of those turning points. I really do think Asheville has a new kind of development model and one that is business oriented and less friendly to small businesses and boutiques. I don't think Asheville will be all that changed in a decade or a generation, but I do think they have a problem with affordable housing downtown."

OSCAR WONG: "In the short term, it will continue to be a busy, special place to visit. At some point between traffic and excess it could lose some of its charm, and we have to be careful about that. There's a fine line."

BIBLIOGRAPHY

T he majority of research for this book came from personal interviews with more than forty-five people. I also have written many magazine articles about Asheville over the years, especially for Blue Ridge Country magazine, and referred back to them. Other sources consulted include the following.

BOOKS

Terrell, Bob. *Historic Asheville*. Alexander, NC: WorldComm, 1997.

ARTICLES

Asheville Citizen. "Bets Paid Off Asheville Downtown in the '80s, '90s." September 6, 2009.

———. "A Different Plan: Lantzius' View of Downtown." October 25, 1980.

———. "Downtown: There Are Two Sides to the Story." October 6, 1980.

———. "Downtown to Be 'Wrapped.'" April 16, 1980.

———. "11-Block Area in Downtown Ruled Blighted." November 2, 1980.

———. "George Willis Pack: Donor of Library Building and Two Public Parks." April 17, 1949.

Asheville Citizen-Times. "Downtown Asheville 'Wrapped.'" April 20, 1980.

———. "The Downtown Shopping Complex." October 18, 1981.

————. "George Pack City's Greatest Benefactor." December 15, 1983.

————. "Haynes Donates $500,000 to Asheville Habitat." July 25, 2014.

————. "Remembering Guastavino." June 8, 1986.

————. "Riverfront to get $50 million makeover." March 22, 2015.

Asheville Times. "Lecture Will Remember Guastavino." July 16, 1990.

Mountain Xpress. "The Asheville Miracle: A Startling Look at Downtown 20 Years Ago and the Folks Who Transformed It." May 25, 2010.

————. "Diamonds and Drugs, Guitars and Guns." July 27, 2005.

————. "It Takes a Village: How a Cast of Thousands Transformed Downtown Asheville." September 17, 2014.

INDEX

INDEX

INDEX